30-MINUTE PORTRAIT DRAWING for BEGINNERS

Easy Step-by-Step Lessons and Techniques for Drawing Faces

callisto
publishing
an imprint of Sourcebooks

Published by Callisto Publishing LLC C/O Sourcebooks LLC
P.O. Box 4410, Naperville, Illinois 60567-4410
(630) 961-3900
callistopublishing.com

Printed and bound in China
OGP 2

CONTENTS

INTRODUCTION

Welcome to *30-Minute Portrait Drawing for Beginners*! You're about to embark on an exciting journey to develop and hone your portrait-drawing skills. Whether you're a casual doodler, have dabbled in **portraiture** (the specific act of drawing portraits), or have never drawn before, this book will guide you through straightforward, step-by-step instructions and techniques that build on this creative skill set.

The goal of this book is to help you learn how to actually draw a portrait, not just trace or copy faces. These step-by-step instructions are especially useful for tracking your progress and guiding your developing skills. Ultimately, you'll be able to take everything you've learned and draw a portrait from scratch using the techniques presented in this book.

Exercises are broken down into bite-size chunks designed to be completed within 30 minutes. Whether you want to dedicate time to an exercise every night, on the weekends, or during a random Tuesday lunch break, you can set your own schedule—all you need is 30 minutes. Complete these exercises one at a time, and feel free to spend time practicing outside this book.

Learning any skill takes time, so go at your own pace and be patient with yourself. This book isn't about perfection or even becoming a professional portrait artist; it's about building on small successes while engaging in a creative and rewarding artistic pursuit. Whatever your experience level may be, just remember: Practice makes progress!

One last piece of advice: Take a moment to recognize all the progress you make. Celebrating your burgeoning portraiture skill set is important and can bring a whole new level of enjoyment to the learning process.

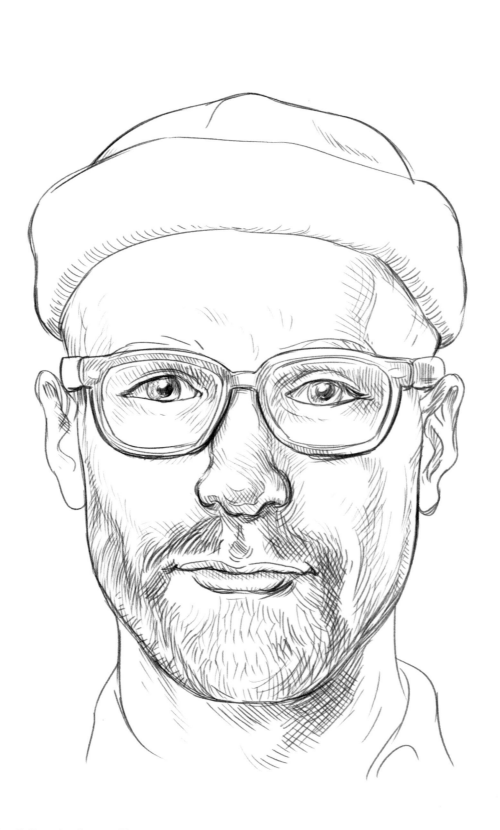

CHAPTER 1
Getting Started

Before you learn the basics of portraiture, you'll need a few things to get started. In addition to a summary of what to expect in the exercises, this chapter will go over the supplies you'll need for drawing, including touching on mediums besides pencil. We'll discuss how to set up your creative space—even if it's not a dedicated art room or study—and we'll provide some tips to help you feel successful and make progress in this new discipline, along with some ideas to keep in mind to help you stay motivated while learning.

Your Art Supplies

You can complete a basic drawing with an everyday No. 2 pencil and sheet of paper, but having proper art supplies can elevate your learning. Here are some items to consider getting to improve your portrait-drawing experience. You can find all these items through an online vendor or at a dedicated art supply store.

Pencils and Pens

Drawing instruments will be your most important tools here. Standard pencils are fine for sketching, but not necessarily for portraiture. Art pencils, on the other hand, are designed specifically for drawing and are well-suited for **blending** (smoothing two areas to transition into each other) and erasing. B pencils have soft lead with darker **shades** (how much black is present in a color)—perfect for the main **linework** (the lines in art drawn by pen or pencil) in your drawing—but their lines are more difficult to erase. For more expressive drawing that incorporates blending and **smudging** (smoothing pencil strokes to create a soft look), graphite drawing pencils are a good choice. H pencils have lighter shades and harder lead, making them good for shading as well as general drawing and art.

You'll also want at least one good pen, especially for portraits with thick, dark lines or layering pen strokes with pencil. Drawing pens, which use a special metal tip called a nib, cause less ink spillage and offer more precise control. When you start with portraiture, a 0.7 mm nib will suffice.

Sketch Pads, Sketchbooks, and Paper

You'll be erasing a lot in portraiture. Mixed-media or heavier weight drawing paper will be important. You'll want paper that can withstand a lot of erasing and redrawing (and more erasing) and allows you to incorporate more than pencil as you progress. For most drawing media, 70 to 80 lb (100 to 130 gsm) paper should suffice, but you'll want to go thicker and heavier when using mixed media such as watercolors or charcoal in your drawings.

Sketch pads and sketchbooks are great, especially when starting out: All your work is in one place, it's easier to maintain sketch dimensions, and you can refer to or compare past works. A4 paper is the best bet—in portrait orientation, naturally. This is roughly the same size as your standard 8½-by-11-inch sheet of paper—enough space to work on your portraits without feeling overwhelmed.

Erasers and Other Tools

Different erasers serve different functions. Standard plastic or vinyl erasers are a great place to start. Keep them clean by periodically rubbing excess graphite buildup off onto some scrap paper. Alternatively, an eraser stick—a mechanical pencil-like casing filled with an eraser instead of graphite—is good for precision but can be rough on your paper. After the edges have been worn down, you can cut plastic, vinyl, and eraser tips with a knife for precision. Kneaded erasers have a lot of utility: They pick up graphite rather than rubbing it off, so they're gentler on paper, and they're also a useful tool for smudging and blending graphite. To clean it, pull it apart and fold it in on itself. Eventually, it will become so covered in graphite that it will need to be replaced. Use some scrap paper to test your eraser before use to see if it's still picking up graphite or just smudging it. Each type has its own strengths, so play around and see what works best for you.

Other Mediums to Consider

While portrait drawing primarily involves pencil work, consider what other mediums you might try. Using pens for line work is obvious, but what about creating a background with watercolors or using markers and colored pencils to add personality and mood? Also consider using charcoal for shading and **texture** (the way a drawing replicates the feeling of three-dimensional physical surfaces) to make a piece more dynamic. You'll want to get the fundamentals down first, but remember that portraiture is just a genre of drawing and you can always switch up the medium if you're feeling inspired.

Your Drawing Space

You don't need an entire room or fancy studio to start portrait drawing; you just need a place to sit, ideally with a table, comfortable chair, and good lighting, especially natural lighting. If your drawing space doesn't have windows, use a bulb that offers naturalistic light. Check your bulb's CRI rating (Color Rendering Index, a number out of 100): The higher the number, the closer your color temperature will resemble sunlight. Color temperature may be listed in kelvin: Around 3500K is white, and a lower or higher number indicates warmer or cooler lighting, respectively.

A calming room, free of clutter, and ambient sounds or calming music can prevent distraction and promote focus. At the end of the day, though, all you truly need is a sketch pad and a place to sit.

Playing with Values

Shadows make a subject or setting feel real. Rounded, sharp, hard, soft—the shadows help set a mood. Let's go over some aspects of how you can capture different shapes or moods of shade. First, let's define a few terms.

- **Value:** How much darkness the color has. The higher the range of value present in a drawing, the more realistic its lighting will appear.

- **Shadows:** These are areas with less light, usually because something is blocking off the light. For instance, a hat casts a shadow over a face. In portraits, you'll mostly be concerned with smaller, focused spots of shadow, such as in the wrinkles of skin or along the neckline.

- **Highlights:** These are areas where the most light is hitting an object, so they will have a lighter **tint** (the amount of white in a value). Often, highlights will be unmarked sections left blank/white to indicate they're "bright" spots—a shine on a forehead or cheek, for instance.

Before we get into portraits, let's get familiar with value scales. Experimenting with different media such as pencils, inks, or watercolors will help you develop your own style.

1. **Create a value scale.** Using pencil, draw six boxes side by side. Starting on the right side, shade in the box as dark as you can. Work your way leftward, lightening the pressure with each box, filling them in with increasingly lighter values. To make darker lines, press harder at the tip of the pencil; lighter pressure will create a lighter shade.

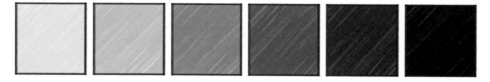

2. **Try hatching and crosshatching.** These are common types of shading that involve using lines to create a sense of shadow. Lines closer together imply darker shades. **Hatching** uses parallel lines, while **crosshatching** uses intersecting lines. Experiment by creating some value scales using these techniques.

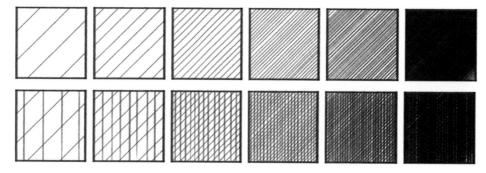

3. **Experiment with ink.** Ink works differently than graphite because it is one uniform shade. Pressing lightly or harshly may thicken the line, but its darkness should be consistent. One shading technique is stippling, in which you make dots, placing them closer together to create the illusion of a darker shade. Start with a few dots spaced farther apart and continue until you have many dots bunched up together, with more dots than empty space.

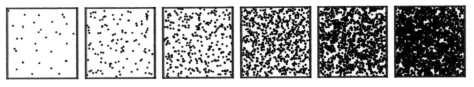

4. **Try charcoal.** Used as a medium, charcoal is an ashy, potentially messy material that creates a textured, rich result. If you have charcoal to work with, practice value scaling. It will function similarly to graphite but can be trickier to wield. You can draw your six boxes with ink to help keep things organized.

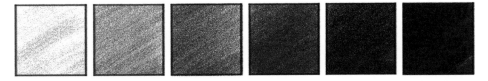

5. **Dabble in watercolor.** Watercolor paints are concentrated pigments that can be mixed with water to create a natural-feeling paint stroke. Laying down a base of watercolor works great as a splash background for portraits, but you can also use it for shading over your main drawing. Use black or gray watercolor to create a value scale. Start at the right side, making a darker shade with a lot of pigment in a small amount of water, then gradually add more and more water to lighten the shade as you work leftward.

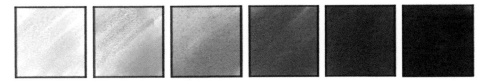

Drawing Portraits 30 Minutes at a Time

Learning a new skill like portrait drawing can be accomplished in bite-size chunks of time. You don't have to spend hours every day on it, but consistency does make a difference. Spending even small amounts of time practicing each day helps you retain techniques and develop muscle memory for future projects. In these 30-minute exercises, the goal isn't necessarily to execute a complete portrait, but to spend time developing hands-on experience using different techniques to master the elements of portrait drawing.

Finding Time

Life gets busy, and it can be challenging to add something else to your schedule, even if that something is for fun. Make a commitment to yourself to find a 30-minute chunk of time once a week and block it off on your calendar, just as you would another obligation. If you're unsure where to start, try laying out where your time goes. Do you spend time on "filler" events, like watching TV, using your phone, or waiting for something to begin? A bit of restructuring can convert some of this time into something more edifying, like drawing.

Drawing can be cathartic, even if it does take focus and energy. Treat it like any other regularly scheduled task and allow yourself the time to learn this skill.

Meeting Challenges

As you work through these exercises, it's likely that you'll come across something you find particularly challenging. This is totally normal. Just remember, practice makes progress, and every mistake is an opportunity to learn. Remind yourself that developing a skill takes work and you can move at your own pace. You don't have to set a deadline to finish a project. Instead, focus on consistency until you reach a stopping point you're satisfied with. Allow yourself breaks, and if you're really frustrated with a particular exercise, try brushing up on a previous skill instead or just draw for the sake of it without worrying about the result.

Having Fun

The whole purpose of learning to draw in your spare time is to enjoy it. If certain factors are taking away from that, consider what you can do to change this. For instance, are you feeling pressured or rushed when you draw? Consider what you can change (for example, your environment, time slot) to take that pressure off of yourself. Choosing subjects you enjoy, care about, and are interested

in can affect the creative outcome for the better, regardless of what type of art you're making. Also, focus on how your skills are growing rather than the result. Do you feel like you really excelled in your shading technique? Great job! Does the hair on your subject really shine? Fantastic! Celebrate these little victories along the way. Before you know it, you'll be executing techniques without really thinking about them.

How to Use This Book

The exercises in the following chapters are designed for you to build on your skills sequentially. They aren't intended to tell you *what* to draw, but rather *how* to draw portraits. The skills you'll develop should be used with your preferred subjects. You can draw from life, observing a real person as you draw, or you can pick subjects from photographs, memory, or your imagination. Your subjects don't have to be real people—you can even recreate fictional characters in your own portrait style. Or perhaps you might enjoy working through a sequence of people you care about. Because portraits are about capturing a person's likeness in a drawing, it's good to draw subjects you're enthusiastic about.

In chapter 2, we'll start by focusing on framing the face. This entails building a good foundation, which involves proper **proportions** (the way objects relate to each other in size or scale) and spacing on a face. In chapter 3, we'll go over how to capture specific features, which will help your portraits begin to look more like specific subjects. Chapter 4 is about depicting different expressions, as well as how to draw from different angles. This will help add **tone** (the amount of light or darkness based on how much gray there is) and personality to your drawings. In chapter 5, shading and light are the target, a pivotal component of any visual art and one that will help your portraits look three-dimensional. Finally, chapter 6 provides exercises centered on filling in texture and detail, which help a portrait feel really authentic.

As you work through this book, keep in mind these exercises are meant to take about 30 minutes. The goal is to get hands-on practice with different techniques, not necessarily to finish or perfect each drawing as you go. Complete each technique one at a time, building on what you learned in previous exercises, with the goal of drawing a finished portrait by the end of this book.

So what are you waiting for? Grab your pencil and sketchbook, pull up a chair, and get ready to draw!

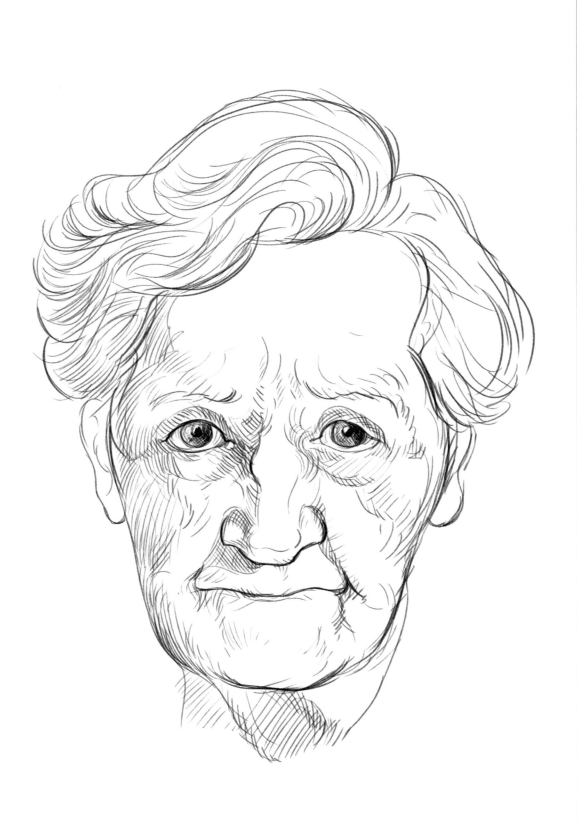

Exercise 5, page 24

CHAPTER 2

Framing the Face

The foundation of drawing portraits is depicting the subject's proportions correctly. A portrait can look off if shapes aren't sized correctly. Eyes may be the same size but, depending on how the face is framed and other factors, the literal sizes of those eyes will look different when drawn. And it's not just about proportions: Knowing where to place the parts of the face is key. We'll cover some tricks that will help with both of these aspects, then get you started with exercises that provide practice with this important skill.

Exercise 1: Creating a Grid

A primary cornerstone to drawing portraits is the basic understanding of how the human skull is constructed. People are not perfectly symmetrical, and everyone is different. When depicting adult faces, proportions can usually be learned using a method pioneered by artist Andrew Loomis. The **Loomis technique** involves dividing a sphere into four parts using **crosslines**, intersecting perpendicular lines that guide the placement and proportions of facial features. In this book, we'll use our own variant of the Loomis method.

1. **Frame the face.** First, draw a circle two-thirds of the way up your canvas (it's okay if it's not perfectly round). Then draw a cross through it, the lines intersecting in the middle. Add a square inside of the circle, with the corners touching the circle border. This circle will serve as the main "skull" reference, but remember that skulls have jawbones attached beneath them. You'll use the horizontal lines to determine the placement of parts of the face.

2. **Outline the chin and head.** Use the square's vertical lines to locate the sides of the skull and the width of the upper jaw. The **jawlines** begin at the bottom corners of that guide square, starting at a slight angle before curving down and in toward the middle bottom of your page. Draw a chin connecting the jawlines, with its center lining up with the middle vertical crossline from Step 1.

3. **Locate the eyes vertically.** Think of the middle horizontal crossline as your **brow line**, a guide for where the eyebrows are placed. Draw a horizontal guideline just below the brow line. We'll call this our **iris line**, a guide for where the eyes will go.

4. **Locate the eyes horizontally.** Draw six vertical lines, spaced evenly apart, creating five sections along the iris line. The brows and eyes will rest within the two sections on either side of the middle section. Draw the basic lines for the eyes and brows, with brows resting along the horizontal crossline from Step 1 and the eyes placed along the iris line from Step 3. The inner and outer corners of the eyes should line up with the length of the brows, while the irises will be almost in the middle, slightly toward the edges of the face.

continued >>

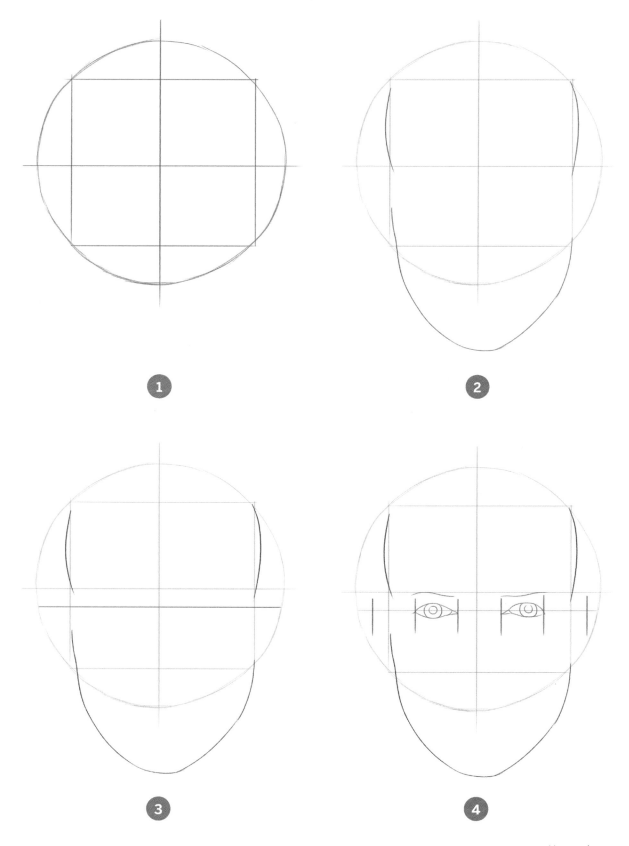

continued >>

5. **Find the nose.** The shape of the nose will vary; it is often as wide as the distance between the inside corners of the eyes. Draw vertical lines down from the inner eye corners to the bottom horizontal line, then draw nostril edges along them. Round out the space in between, filling in the nose to meet at the centermost vertical line of your initial cross and adding some shape to show the **bridge** of the nose curving up and inward.

6. **Find the mouth.** Mouths will vary, but the corners generally line up below the pupils. You can draw vertical guidelines from the pupils down to the bottom of your circle to locate the edges of the mouth, with the center crossline marking the middle of the lips.

7. **Add the ears.** Ears are usually in the space between the brow line and the bottom of the nose. Use the brow line to locate the top of the ear and decide where the lobes end, somewhere before the bottom nose line.

8. **Add the hair.** The hairline will usually reside along the top horizontal line of the square guide from Step 1, stopping just before the left and right sides of the skull and trailing downward toward about where the brows lie. We'll cover how to add texture and shading in later chapters.

We've darkened the lines and removed the guidelines in the final steps of these exercises. This entails erasing your guidelines as you progress and strengthening those you wish to keep. You are encouraged to do this yourself, but it's not required to practice the skills highlighted. We've included these images to help you see what the end result can look like.

> **TIP**
>
> These guidelines are literally that: Guides! All faces vary and some will adhere to these approximate measurements more than others, so don't worry if the face you are drawing doesn't exactly fit the guidelines.

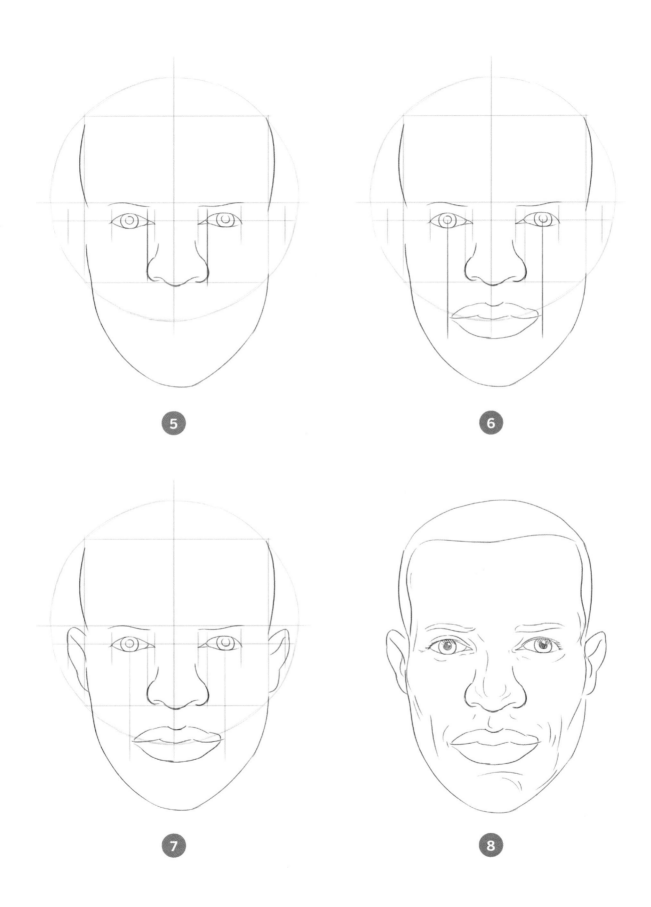

Exercise 2: Developing Your Grid

Learning the basics of drawing facial proportions can be challenging. You'll need to practice a lot to improve. For this reason, we'll do another exercise using the same process as in Exercise 1 while implementing some variation.

1. **Frame the face.** Draw your initial frame of a circle, cross, and square as we did in Exercise 1.

2. **Outline the head.** Lay out smooth, curved lines on top for the basic outline of the hair. Add the jawlines and chin on the bottom using your square's vertical guidelines. Remember to place the chin so it is centered along the guideline.

3. **Add the eyes.** Locate your brow line and add eyes below, again dividing into five even sections. This time, draw eyes that are a bit smaller and brows that curve more.

4. **Add the nose.** Working with the bottom of your square, draw the nose, using the inner eye corners as a guide to align the nostrils.

TIP
Sometimes we can focus too tightly when we're observing our subjects. The guides are useful because they get us into the habit of seeing each feature in relation to everything else around it!

continued >>

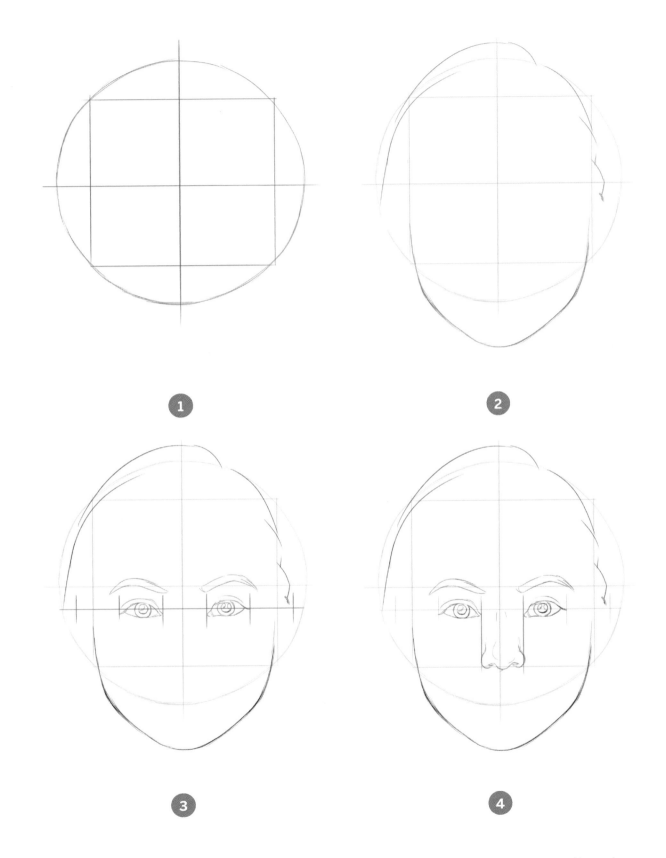

1

2

3

4

continued >>

5. **Add the mouth.** This mouth is narrower. As a guideline, we've used the inner edge of the iris rather than the pupil, and we've added some teeth showing for variation.

6. **Add extra features.** You can cover both ears with hair, though an uneven style will be good practice. The top of the ear should line up with the top of the eyes, and end about where the nostrils begin. We've also included eyeglasses, which rest against the bridge of the nose along the cross of the iris line from Step 3. You'll see we use the vertical sides of the square to measure the width of the glasses, and then we've added length to the hair.

7. **Emphasize features.** Add some detail to the irises. Start the eyelashes at the edges, and begin adding slight shading below the brows, nose, and hair. Shade along the neck, adding thinner strips of shading below segments where hair is present, like the sides of the forehead and below the brows. Eyelashes generally curve away from the eyeball.

8. **Add details.** Add additional smaller, lighter lines to hatch out some basic shading, and fill out the hair. The hair in this exercise is mostly straight, so adding extra lines that follow the path of the hair can easily add **depth** (the sense of objects or parts being closer or farther away).

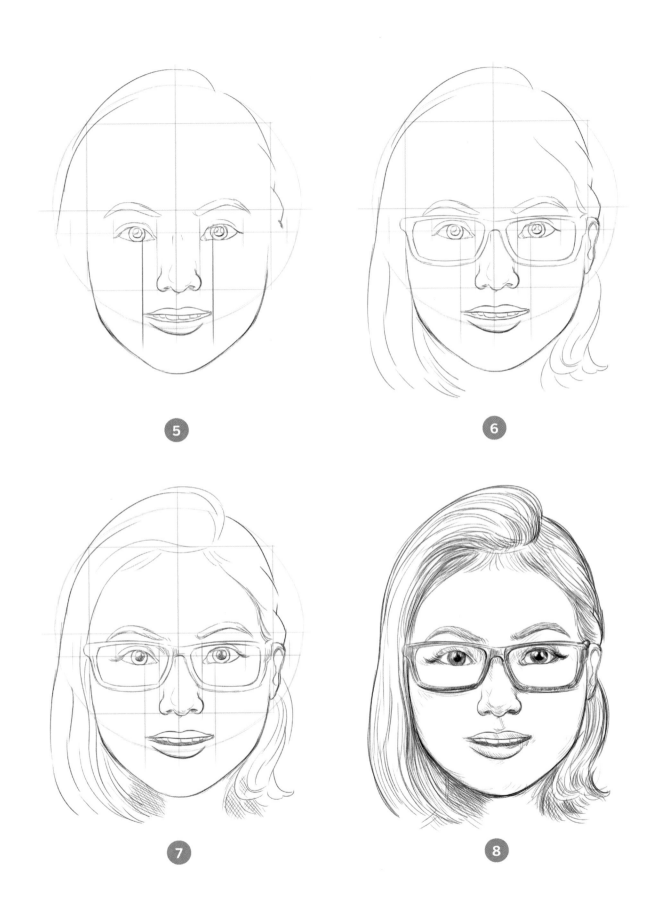

Exercise 3: Grid Variations

Let's practice our modified Loomis method again while creating a face with different proportions than in Exercises 1 and 2.

1. **Frame the face.** Draw your initial frame of a circle, cross, and square.

2. **Begin the hat and add the jawlines.** We'll draw a hat this time. Use the upper intersections of the cross and square as reference for where the hat will wrap around the skull. Add the jawlines and chin.

3. **Add the brows and eyes.** Use your guidelines to keep the eyebrows and eyes lined up. This time, make the brows flatter and thinner.

4. **Add the nose.** Again, the inside corners of the eyes help you locate the sides of the nostrils. Try a nose with a wider shape.

continued >>

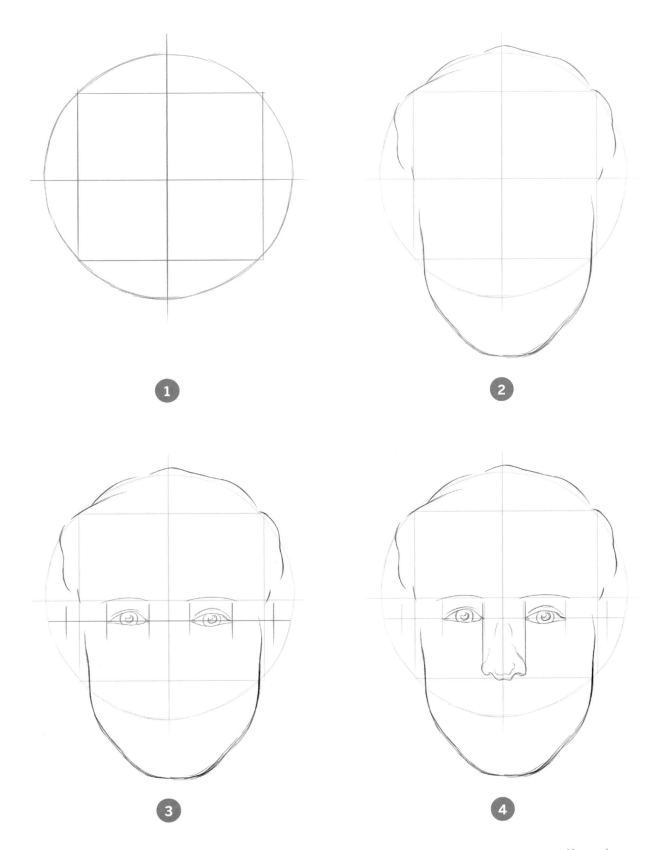

continued >>

5. **Add the mouth.** Use the irises to measure the length of the mouth. Go for a thinner mouth with a bottom lip that is noticeably shorter in length.

6. **Add the ears.** Line up the bottom of the earlobes with the square's bottom and align the tops of the ears just past the iris line.

7. **Add apparel.** Include a bit of neck and the shirt collar if you like, but focus mostly on finishing the basic lines of the hat. Feel free to add glasses but try a different shape and style.

8. **Add details.** Some light hatching makes a difference, bringing depth and shape to the face. We've added some facial hair. Notice how the facial hair lines look compared to the light shading elsewhere. We'll get into that a bit more later.

> **TIP**
>
> Try varying the pressure of your mark-making. Use stronger marks on the page when drawing lines you feel are important.

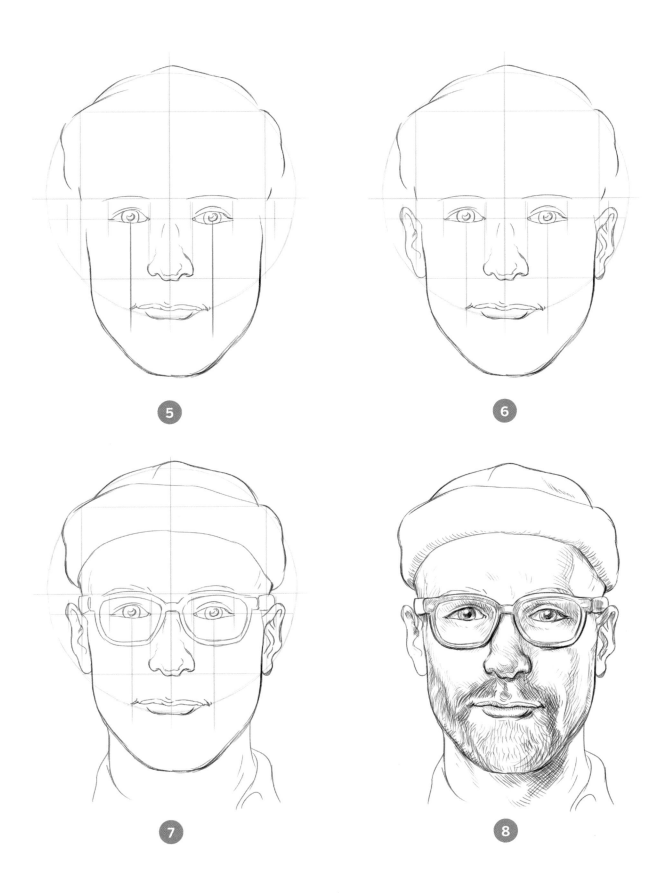

Exercise 4: Babies and Children

Now let's try working on a younger face. Babies and children tend to have different facial structures, with features set lower on their faces and eyes spaced farther apart. Let's use what you've developed so far to draw a younger child's face.

1. **Frame the face.** Draw your initial frame of a circle, cross, and square, this time with a circle inside the square. Include two extra horizontal guidelines, sectioning out the square into eight segments.

2. **Outline the skull.** Unlike in the previous exercises, the entire skull should fit inside the frame, and the top of the skull should be wider. Use the top two horizontal segments of the square to mark the round top of the skull shape, the third sections down to transition to the temples and upper cheeks, and the bottom segments for the jawlines and chin.

3. **Add the brows and eyes.** The same basic rules apply here: The center crossline is your brow line. Divide a slightly lower horizontal line into fifths to determine the position and width of the brows and eyes.

4. **Add the nose and mouth.** As before, the irises guide the corners of the mouth and the inner corners of the eyes guide the sides of the nose. Notice how the proportion change makes the face look different, even though the parts of the face are still pretty similar in relation to one another.

5. **Add the hair.** Try adding some puffy, curly hair to practice a different style.

6. **Add details.** Like prior exercises, you can fill the volume of the hair with more lines, mix in lighter lines for variety and depth, and fill in basic shading to facial features. Try to create different types of textures with this younger face.

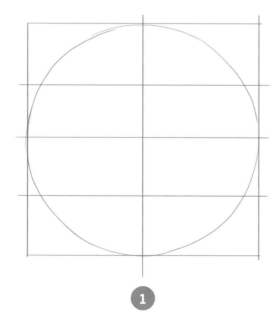

1

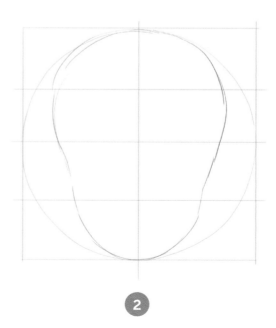

2

Exercise 5: Older Adults

As we age, our faces naturally change. In addition to smile lines and other wrinkles, our ears and noses tend to elongate, our eye sockets may widen, and our cheekbones and muscles can lose their firmness. We'll draw an older face in this exercise.

1. **Frame the face.** Draw your frame of a circle, cross, and square.

2. **Outline the head.** Start to form a basic hair shape and sketch in the cheekbones, jawline, chin, and neck. Notice that the jawline recedes inward from the cheekbones more, and the chin appears more separated from the jawline.

3. **Add the brows and eyes.** You know the drill, but this time make the eyebrows more like an implied shape of spaced-out hairs rather than a singular shape. Note how the upper eyelids are much wider and the eyes appear smaller overall.

4. **Add the nose and mouth.** Use the irises and eye corner guidelines, as before. Because the eyes are narrower, but the nose edges still line up with them, the nose feels wider. The lips are also thinner, making a mouth shape that's more like a single line rather than three.

5. **Add hair volume and basic details.** Wrinkles will help shape the **definition** of the face, bringing clarity to its appearance as a three-dimensional object. An older person's wrinkles tend to be longer and much more plentiful than those on a younger face. Add multiple curved lines that follow the shapes of the cheeks, jawbone, brow, and forehead.

6. **Add simple detail.** Practicing basic shading will help you get used to adding lines of different tone to create depth. Notice how the shading and simple lines create an uneven depth to the neck's shape.

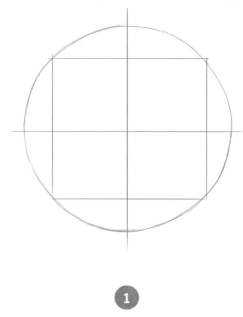

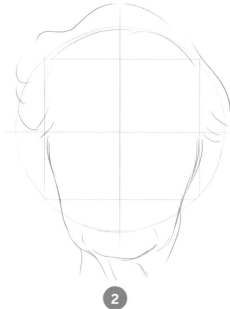

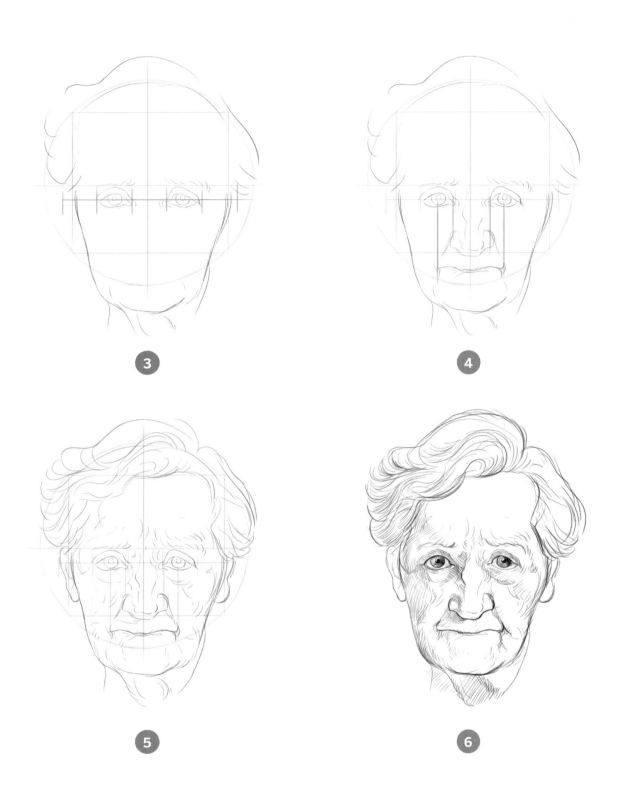

Exercise 6: In Profile

The grid format we've been using will apply, regardless of the angle you're using. A **profile** portrait depicts a face perfectly from one side. We'll look at elements on which we haven't yet focused: the shape of the nose and chin, the slope of the forehead, and the way the ears look when you face them directly.

1. **Create the guide.** Draw three horizontal lines, evenly spaced apart.

2. **Outline the profile.** Use the following guidelines to locate key parts of the profile. Start on the left portion of the middle line, drawing an ovular (like an egg) arc upward and toward the right, forming the forehead and top shape of the skull. The hairline will lie along the top guideline; the ridge of the eye will go along the middle guideline; and the bottom of the nose will lie at the bottom guideline, stretching toward the left before curving in toward this bottom line. The brows will go just above the middle guideline, and the eyes will be set just below. Add an extra horizontal line just below the middle line, to serve as an iris guideline.

3. **Add an eye and ear.** The eyeball is a sphere, and the eyelids cover most of its front side. The iris should lie at the third horizontal guideline, which should also help you locate the top of the ear. The iris will rest beneath the eyebrow, as if it's nestled within the curve of the brow. The top of the ear will begin just right of where the hairline ends, curling up and going slightly over the iris line. The earlobe can extend slightly past the bottom guideline.

4. **Add definition.** Using the illustration as a guide, observe the ways the lines added in this step create the illusion of three-dimensional shape. To help form that depth, many of the lines we've added in this step are parallel with previous lines. We've also added lines to create shape for the side of the ear.

5. **Add shading.** Hatching will add a bit of depth, while the smaller, concentrated areas of overlapping lines will create some shadow. Some areas to focus on include the jawline, brow, hairline, and behind the ear.

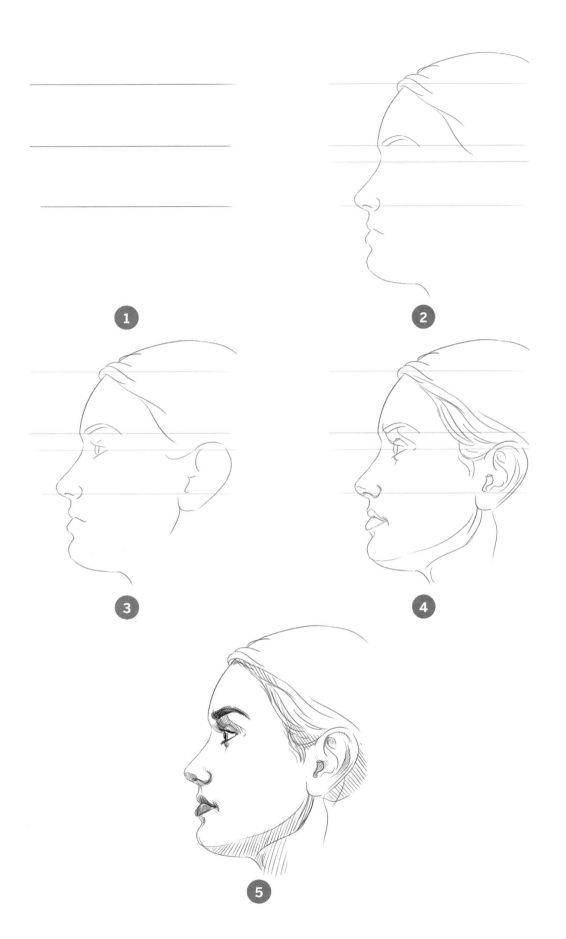

Exercise 7: The ¾ Angle

The **¾ angle**, in which the subject is facing at a 45-degree angle rather than head-on, is common in all types of media. You'll need a good grasp of the three-dimensional shape of the face; it's like combining a typical head-on portrait with a profile **perspective** ("perspective" refers to the way a drawing suggests that the subject exists in three-dimensional space, such as by angle of rotation). Think of each part of the face in terms of smaller shapes being combined and consider how your grid foundation can help guide placement.

1. **Create the frame.** We're revisiting the original guidelines. Draw a circle, a cross that divides it evenly, and a square.

2. **Outline the face.** This time, you're depicting a face from an angle, so the amount of space between the center vertical line and the edge of the face is roughly double on the right side compared to the left. But notice how the proportions for the jawline, brow line, and chin are still the same, vertically.

3. **Add the eyes and brows.** The eyebrows still go along that middle horizontal guideline, with the eyes slightly below it. Add the iris line, if needed. The eye on the right is a bit farther away from the center guideline and appears slightly wider. The brow on the left curves inward before it ends, wrapping around the side of the head. The irises are also not in the center of the eyes, adjusted slightly to our right so they appear to look directly at us.

4. **Add the nose.** The bridge of the nose will be completely to the left of the central crossline and will curve outward. The left nostril is barely visible, and the right nostril pushes to the right of that central line, still meeting up around the corner of the right eye.

continued >>

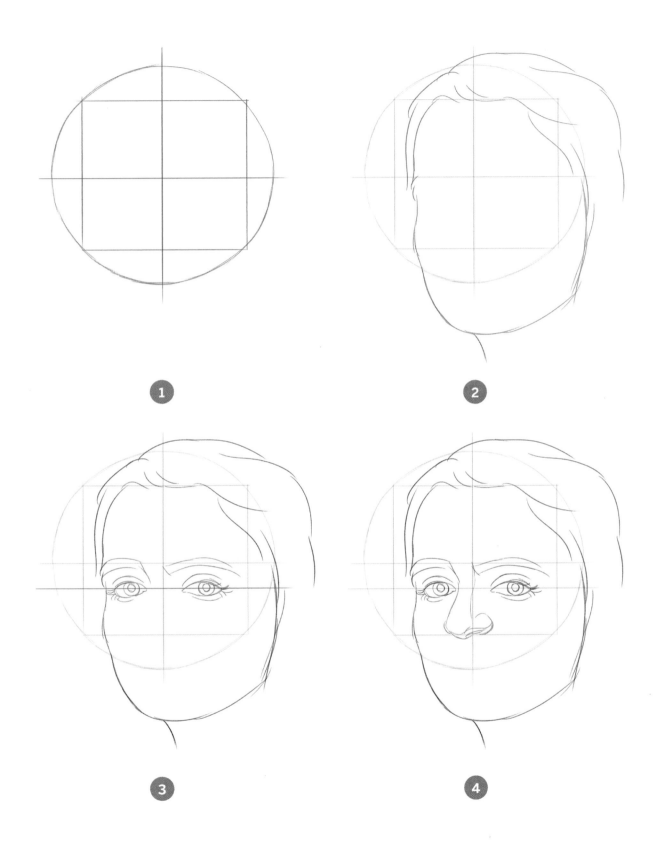

continued >>

5. **Add the mouth.** Maintain the rule noted earlier: The edges of the mouth line up with the pupils.

6. **Add definition.** You can follow the illustration here. Pay attention to how the different lines curve to create the illusion of roundness or depth.

7. **Add detail.** If you're depicting hair, start adding primary lines to shape its flow. Some hatch lines along the side of the face and more focused hatching around the eyes, brows, nose, and mouth will flesh things out.

8. **Add shading.** Crosshatch lines will round out your shadows. Some extra hatching will solidify the shape of the skull, and you can also fill out the hair.

TIP

Experiment with the direction of your cross-hatching and practice making these marks with confidence. Does the quality of the line change along with the direction?

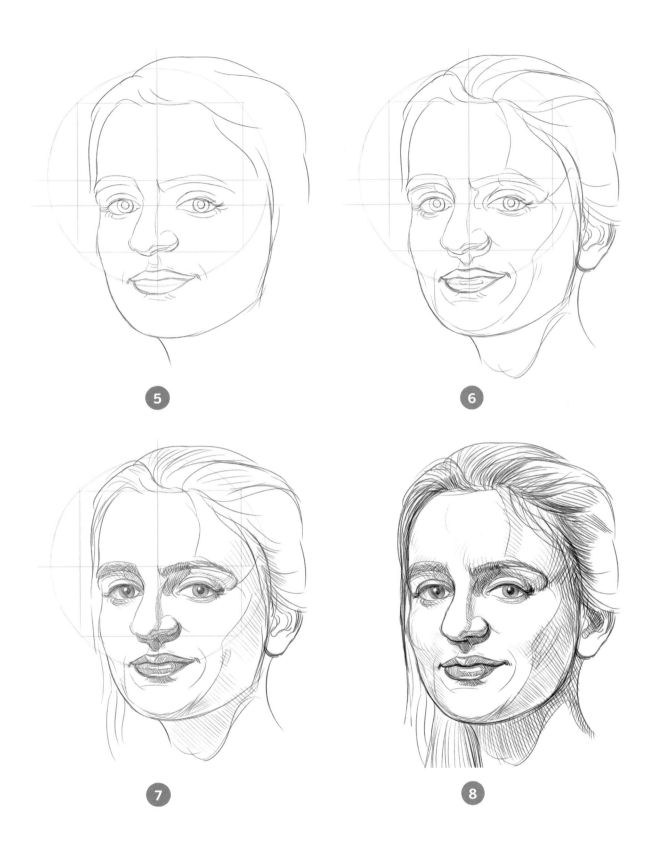

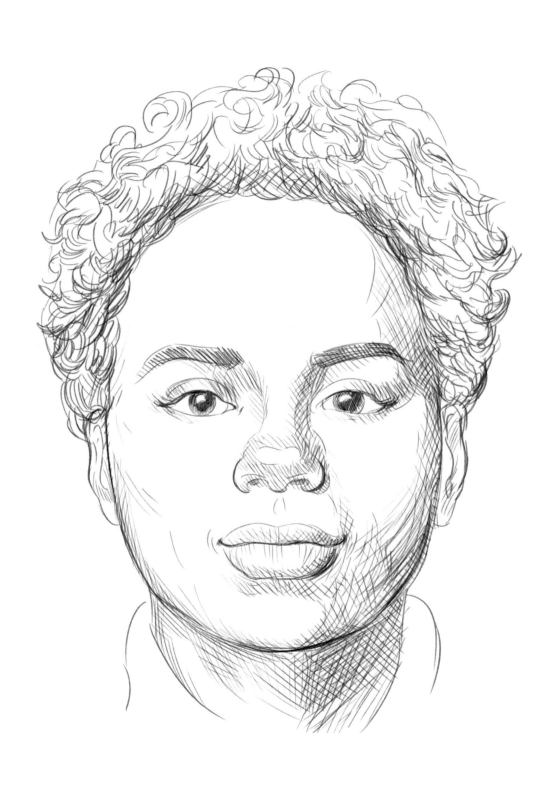

Chapter 4, Exercise 1, page 48

CHAPTER 3
Facial Features

Now that you've spent some time working with the basic foundational grid of a face's proportions, let's hone in on specifics. In this chapter, you'll practice drawing individual parts of the face. We'll start with detailing the eyes and then move on to the nose, mouth, and ears.

Exercise 1: Eyes

The eyes—and the eyebrows set above them—are extremely expressive, and understanding how to depict them is key to giving your portraits life. Practicing with more exaggerated expressions can help you become familiar with how to draw them. Remember that eyes are spheres set in sockets in the skull. Keeping this in mind can help you draw them better, depicting them as three-dimensional spheres with eyelids that wrap around them.

1. **Create a guide.** Think of the guide as drawing a "target" design, using concentric circles with a cross through the middle (sharing the same center, the middle of the cross). The smaller, middle circle is the guide for the pupil, and the outer circles are about four and five times as far from the center. These outer circles will help you keep track of the approximate size of the entire eyeball.

2. **Add the brow and pupil.** The small central circle will be the iris. Add a smaller circle inside it, about half the diameter, to serve as the pupil. Add a brow above the target guide, using the outermost circle as the inner edge of the brow, as well as a guide for the brow's length.

3. **Add the eye's shape.** Remember that the eye is a sphere with skin around it. Create the opening above the iris. There should be edges where the lid opens, with a crease at the top. An extra line on the bottom lid can create some depth.

4. **Add the lashes and definition.** Notice how the lines depicted in the example all curve inward, with the angle getting sharper as they get closer to the inner corner of the eye. The lashes curve in the opposite direction, outward and away from that inner corner.

5. **Add shading.** Use lines that follow the **contours** (the lines that compose the primary shape) you created in the previous step, blending them across to form a gradual change. Where shadows are deeper, there will be more lines, closer together. The lines on the brows should follow the direction the hairs grow—notice here how they point more upward at the inner side, but more horizontally at the outer side. In the iris, most of the lines will point outward from the pupil, but some curved lines crossing over can imply roundness. Leave a bit of blank space to depict the reflection of light in the eye.

6. **Finalize shading.** Some crosshatching can help create a sense of shape and shadow. Follow the example here—and know that we'll get into more detail on shading in a later chapter.

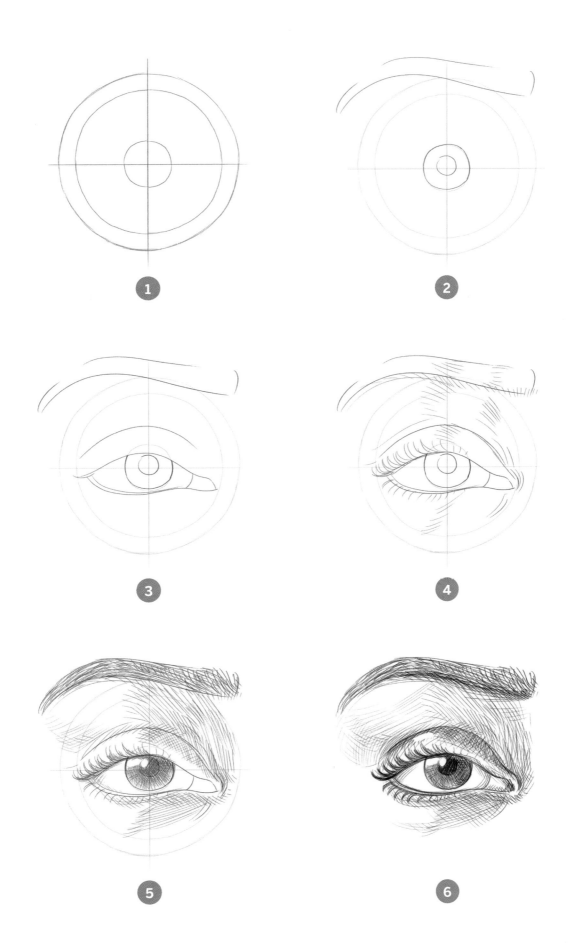

Exercise 2: Eyelids

Eyelids are an often overlooked but important piece of how we convey emotion with our faces. It's important to remember that eyelids are skin that wraps around the eye, so they're not flat, but rounded over a sphere. Eyelids in the same position can communicate very different emotions depending on what else is going on with the face. Narrowed brows could show suspicion or sleepiness, and wide-open eyes might indicate fear or excitement.

1. **Create a guide.** Create the same guide you used in the previous exercise.

2. **Add the iris, pupil, and brow.** You'll notice here that we've set the brow lower than before, and made it an uneven shape. The iris is also a bit bigger than last time.

3. **Add the eyelid.** A crease above the eyelid helps distinguish the shape of the eye socket. Try making this eye appear more closed by shrinking the height of the eyelid opening. You can see we've drawn the upper lid covering part of the pupil, with the lower lid also starting to cover the iris.

4. **Add basic definition.** Notice how we've included extra lines in new places to emphasize the shape of the eye socket, especially around the crease above the eye. We've also added extra lines going in the opposite direction to create a sense of wrinkled skin.

5. **Add shading.** The shading in this example is different than in previous exercises, so feel free to use it as a reference. See how the bottom/middle of the iris is devoid of hatching, while the hatching around the sides is dense. This extends vertically around the eye, helping to create a sense of lighting and shape: The eyelid is closing over and around the sphere that is the eyeball.

6. **Add the final details.** Some extra hatching helps round out the sense of shadow and depth.

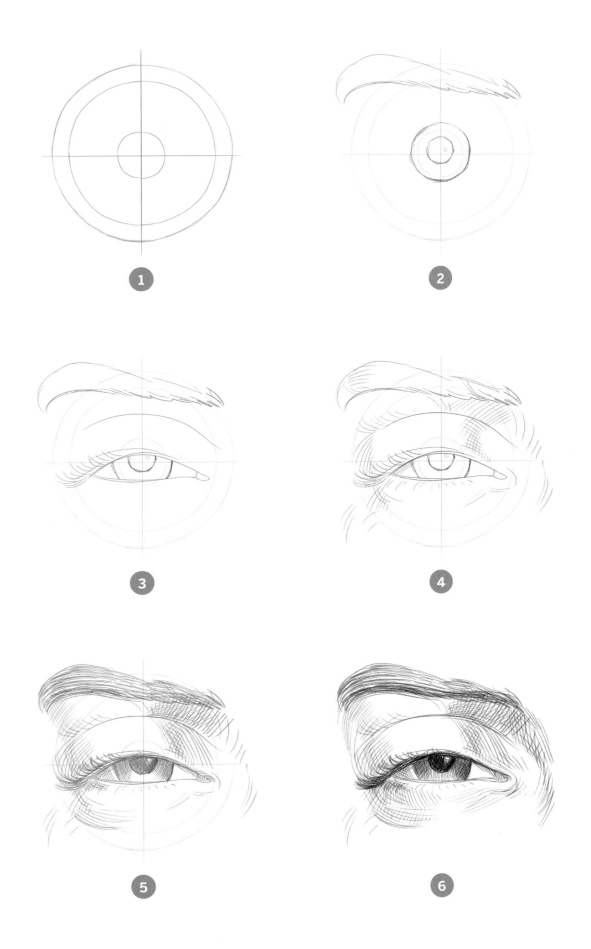

Exercise 3: Eyebrows

If eyes are the windows to the soul, eyebrows are the expressive curtains. Eyebrows form along ridges on the skull. Because of the many smaller muscles in this area, we're capable of emoting a great deal with just our eyebrows; the muscles do the work, and the hairs on top are the visual cue.

1. **Create a frame.** Ignoring the outer circle and square shapes, we'll retain the guidelines we use to place the brows and eyes; recall the five segments we use to determine their width and placement but focus more on the lines themselves. The inner segments are shorter, which will create a different set of proportions for these eyes.

2. **Add the irises, pupils, and brows.** Draw circles along the main horizontal guidelines in the two sections on either side of the middle one. They should be about one-third of the length of each section, and a circle about half as big will go inside, creating an iris and pupil. The brows go above them, along the second horizontal guideline. Here, our brows are bushier, created by an implied shape rather than a solid line.

3. **Add the eyelids.** Creases above, below, and in between the eyes replicate muscles in the face. Remember to follow the shape of the eye itself, like they're wrapping around it. The main two crease lines will consist of a longer one above the eye, stretching across its length, and a smaller one below, on the outer third to half of the eye's length. Add the edges of the bridge of the nose, curving inward. Smaller crease lines just above the bridge of the nose can be used to emphasize the brow muscles slightly.

4. **Add the hair and basic details.** Fill out the eyebrows and add eyelashes, with lines reflecting that hair grows outward. Brow hairs often grow upward, curving away from the center of the head. Eyelashes generally do the same, away from the eye. Add some crease lines above the nose.

5. **Add depth.** Below the brows our shading features lines tilting outward, away from the center of the head, while the lines below the eyes curve inward. Fill in the space within the iris and darken the pupil, leaving a bit of blank space as a light reflection.

6. **Add more shading.** Crosshatching and extra hair lines in the brows will flesh out the detail.

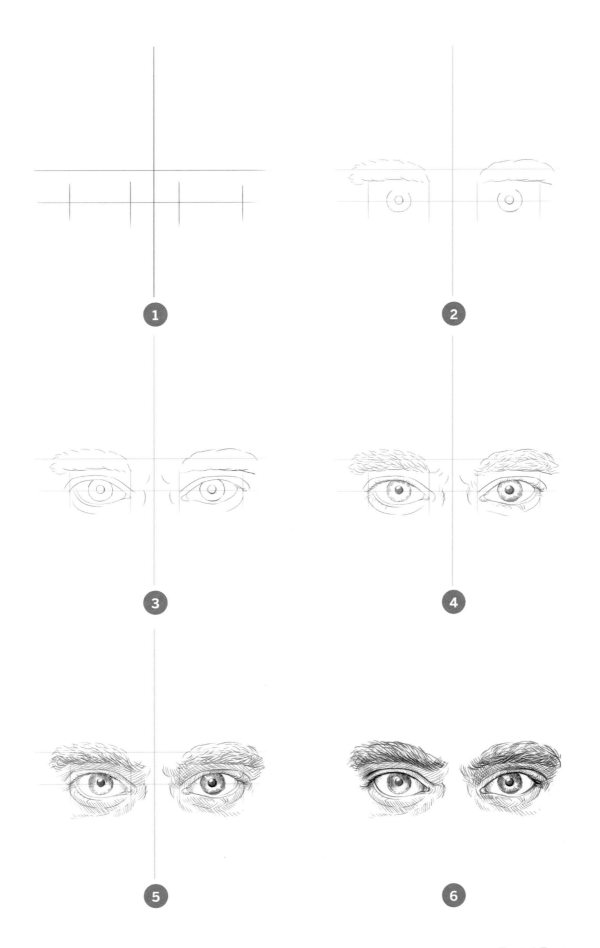

Exercise 4: Nose

When drawing noses, emphasize the bottom lines and shape. You can think of a nose as two perpendicular ovals intersecting at their bases.

1. **Create the frame.** We'll once again use a closeup of our frame from chapter 2, specifically the bottom section from our original grid. Note the central vertical guideline of the cross with two more lines, one on each side. Then add another pair of lines, triple the distance away. This time, extend the length of the vertical guidelines. We'll use them to help locate parts of the nose.

2. **Create the basic nostril shape.** The inner guidelines show you where to put the top of the bridge and where the base of the nose lies. The outer lines guide the nostril edges.

3. **Create contours.** These follow the shapes of the previous lines, so use them to help mark the areas between light and shadow.

4. **Add shading.** Overlay more contour lines with hatching and crosshatching. Notice how the absence of these shading lines, compared to where they're clustered together, implies the shape of the nose.

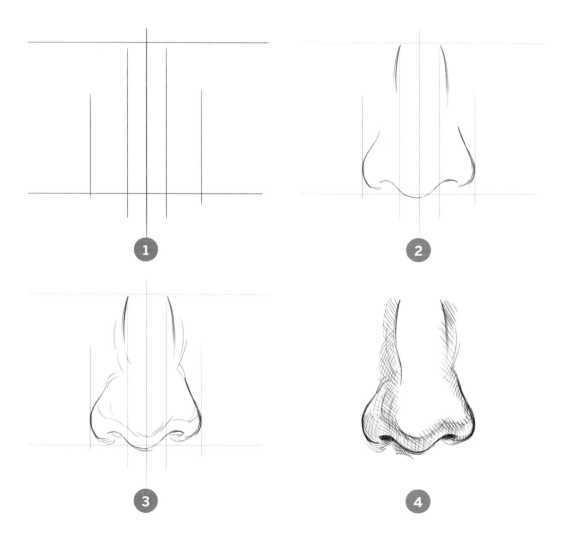

5. **Create the frame.** Draw a fresh frame identical to the previous nose.

6. **Create the basic nostril shape.** This time, add long curves from the nostrils.

7. **Create contours.** This nose is different from the previous one, so follow our example, as needed.

8. **Add shading.** See the spots of white in multiple places? It generates a sense that this nose is uneven in shape.

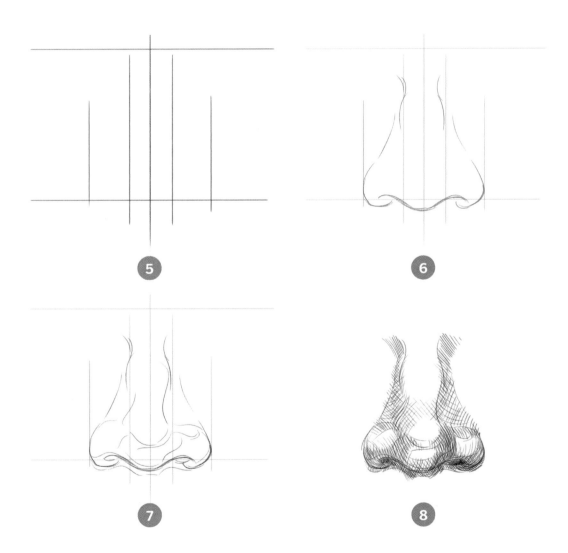

Exercise 5: Mouth

Mouths help form the bulk of recognizable expressions—it's why most emoji have eyes and mouths. Drawing mouths in portraiture can be challenging. The shapes of lips in particular can take some time to master. One helpful tip with mouths: Break down their lines into parts—the upper lip, the middle, and the lower lip.

1. **Create the frame.** Draw a cross through the middle of your frame, then add an extra horizontal line slightly above the center. Add a second horizontal guideline about twice as far away from the center and two vertical guidelines equidistant from the center.

2. **Sketch the lip shapes.** This upper lip is thinner, and the bottom lip is wider but arcs more. The top lip has a slight "bump" toward the center.

3. **Add definition.** Add some basic hatching below the bottom lip to create shadow.

4. **Add shading.** Hatching and crosshatching create depth. The blank spaces cause the lips to appear shiny. The lines on the upper lip are more clustered together to create shadow.

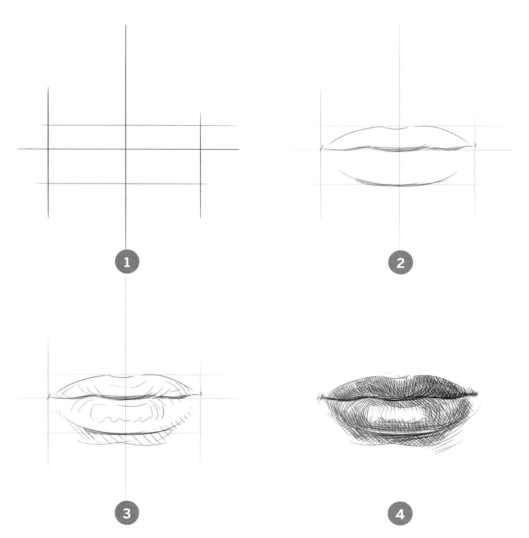

5. **Create the frame.** Replicate the frame from above, but this time the horizontal lines can be evenly spaced from the center cross.

6. **Sketch the lip shapes.** Following the guidelines, these lips appear thicker.

7. **Add definition.** These contour lines help the lips feel more like they "pop," and extra lines in the center give the upper lip some volume.

8. **Add shading.** Hatching and crosshatching will give the lips depth. Note that the shading lines on the upper lip don't quite touch the edge; that space between the lip line and contour generates more volume in the upper lip.

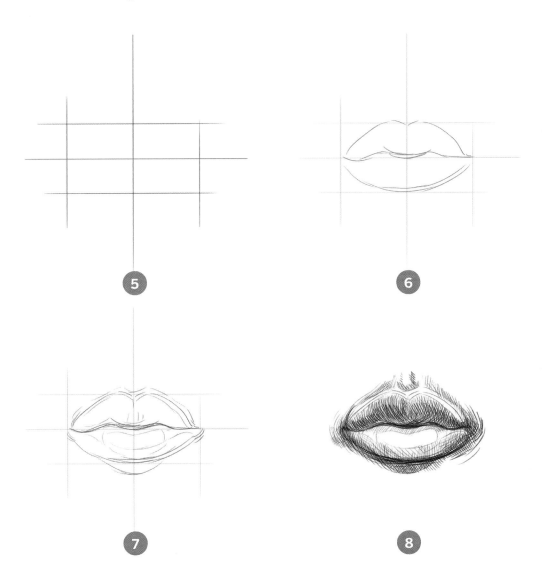

Exercise 6: Ears

Ears usually fall between the brow and nose lines. They are incredibly complicated shapes; learning to depict them can really help you understand light and shape in human features.

1. **Create the frame.** Draw three horizontal lines, evenly spaced apart, with another line further down. This replicates the brow line, pupil line, and the bottom of the square from previous frames we've used.

2. **Outline the ears.** We've depicted the side of a head, including a brow, eye, and nose. The bottom horizontal guideline marks the bottom of the ear lobe; the next line up is where the top base of the ear connects, and the next is where the top of the ear lands. Like eyes, ears are comprised of multiple smaller parts. After the outer line, for example, there is often an upper crescent line that follows the ear's outline, trailing around to form an outer ear "ridge."

3. **Add shading.** Given their complex, uneven shape, even simple shading will make ears more recognizable and provide instant depth. You can shade in the area along the inside of the ridge line, as well as the inner ear section.

4. **Add further shading.** Dark lines versus light ones, as well as blank spaces, help fill out the full shape of the ear.

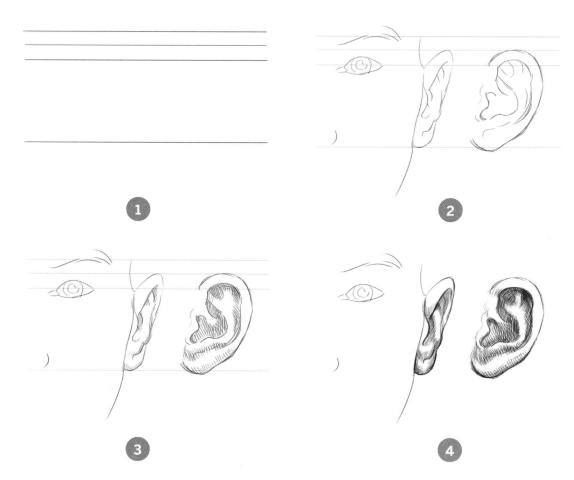

5. **Create the frame.** Use the same frame as the prior ear, or extend the lines made for the first drawing if there's space.

6. **Outline the ears.** The example here depicts an ear with a different shape—the ear is a bit taller, extending to the topmost guideline, and it's at a more straightened angle.

7. **Add shading.** Some thinner shading just below the outer and inner lines adds depth. Add slightly darker shadows close to the ear canal.

8. **Finalize.** Utilize crosshatching to deepen the darker sections.

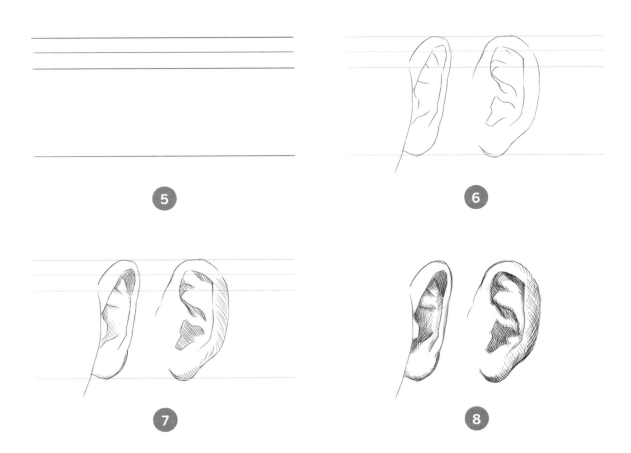

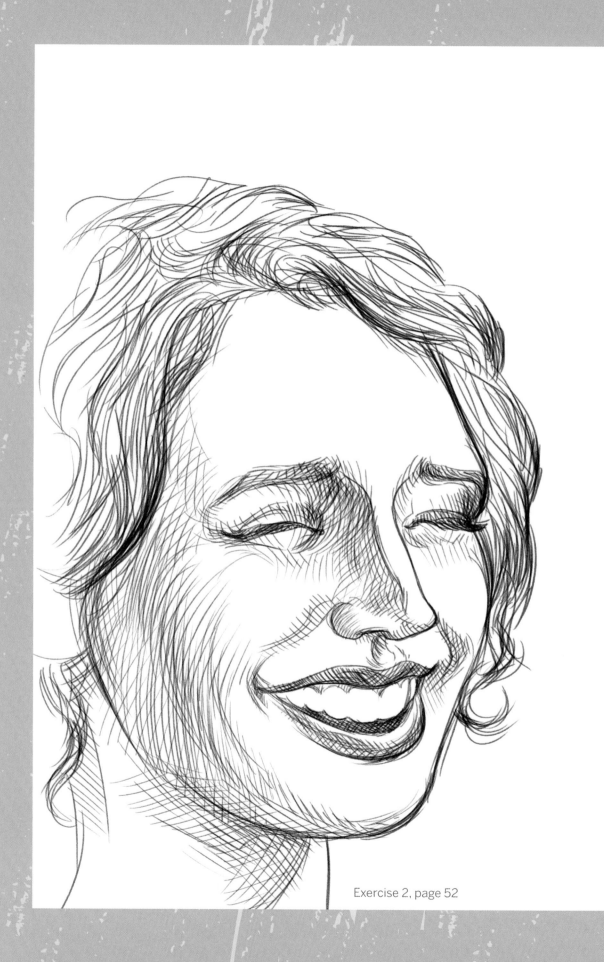

Exercise 2, page 52

CHAPTER 4

Angles and Expressions

Drawing faces already takes a lot of work, but really mastering it requires practice capturing faces at different angles with different expressions. In this chapter, we'll bring together elements from the previous two chapters and explore different ways to add variety to your portraits with perspectives and expressions.

Exercise 1: The Human Face

Congratulations on making it this far! In this exercise, you'll use your own face as your reference. You'll be able to freely pose and angle yourself so you can focus on accuracy in the proportions and detail. A mirror at eye level is best, and you should maintain a neutral expression to see your own features accurately. (We highly recommend that you draw yourself, but if you really don't want to, we've included some steps to follow along with a visual guide.)

1. **Frame the face.** Draw your initial frame of a circle, cross, and square. You can try taking a selfie and overlaying the frame on top to serve as a reference, but drawing by hand will help you practice, too.

2. **Add the hair and jawline.** Use the square guidelines to create the basic shape of your jaw and chin, then use that as a point of reference to create the outline shape of your hair. You can also do this in the opposite order, if you wish.

3. **Add the eyes and brows.** Use the horizontal crossline to add your brows. Remember to add your sectioning lines to help nail the proportions of the eyes.

4. **Add the nose.** Do the edges of your nostrils line up with the inner corners of your eyes? If not, you can always adjust their position.

continued >>

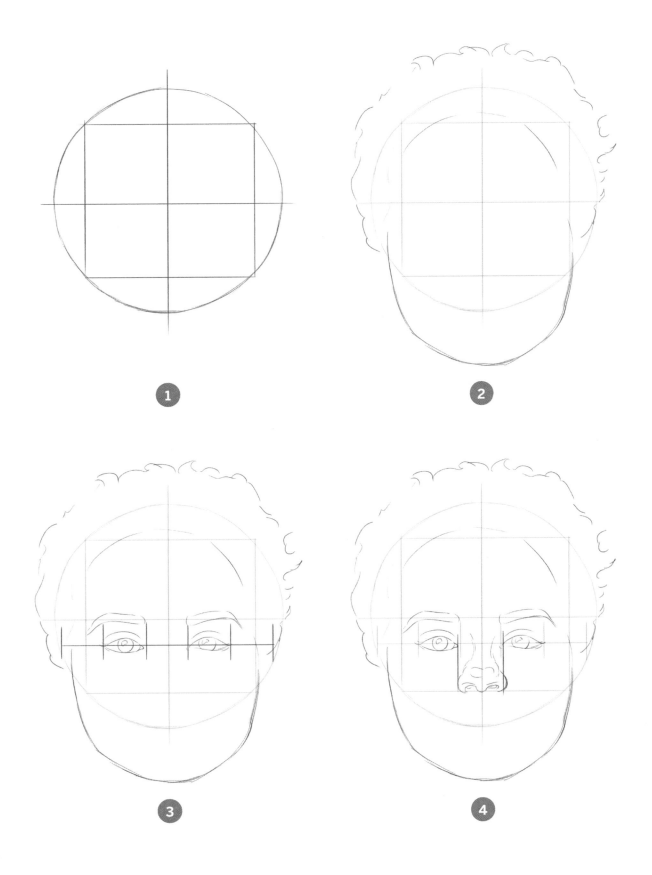

1

2

3

4

continued >>

5. **Add the mouth.** In our example, the lips don't extend to the iris lines, but adding those guides can help keep the lips even horizontally, and the vertical crossline will help you center your mouth shape.

6. **Add the ears.** Use the guidelines from other parts of the face to help you place the top and bottom of the ears.

7. **Add hair volume and basic details.** Start filling in some basic definition to your face and complete the prominent lines in your hair. We've used a sequence of short, curved lines that overlap or connect. Lines around the hairline curve away from the head, while those on the outer edge of the hair curve in more random directions. Some wrinkle lines to consider adding: curving up around the brows and on both sides of the bridge of the nose, curves on the cheeks and jaw that point toward the chin, and wrinkles on the neck that curve inward toward the middle.

8. **Add details.** Try replicating the shading in the reference of yourself that you're using. Don't worry about the details too much—very basic shading is good practice for now.

TIP

Always begin your shading with lighter strokes—it's easier to add than to take away!

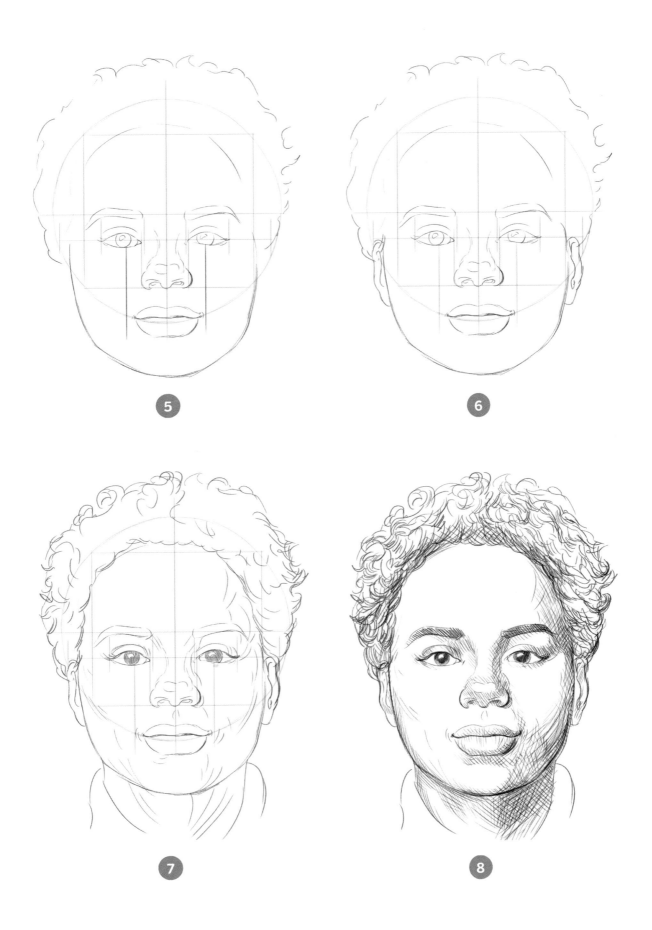

Exercise 2: Joy

Muscles in the forehead, brows, eyelids and eyes, cheeks, lips, and chin can all impact an expression. Smiles, for example, are built from muscles in the cheeks (not lips), with the eyes and brows typically relaxed. When portraying joy, the forehead muscles typically pull upward and the brows move inward.

1. **Create the frame.** Use the same frame we established in chapter 2. This time, we'll draw the opposite side of the face and at a slightly different angle.

2. **Outline the face.** The head will be facing at an angle toward the right. The brow's edge meets at the horizontal crossline, and the chin will be where the vertical crossline is, slightly to the right.

3. **Add the brows and eyes.** The width of the eyes and the width of the brows are asymmetrical because of the perspective. Depict the eyes squinted closed this time.

4. **Add the nose.** Draw a nose with a pointed shape and a flat bridge. The left edge of the nose's bridge should end where the guidelines from Step 1 connect, as should the left nostril's hole. Have the point of the nose line up approximately with the right iris.

continued >>

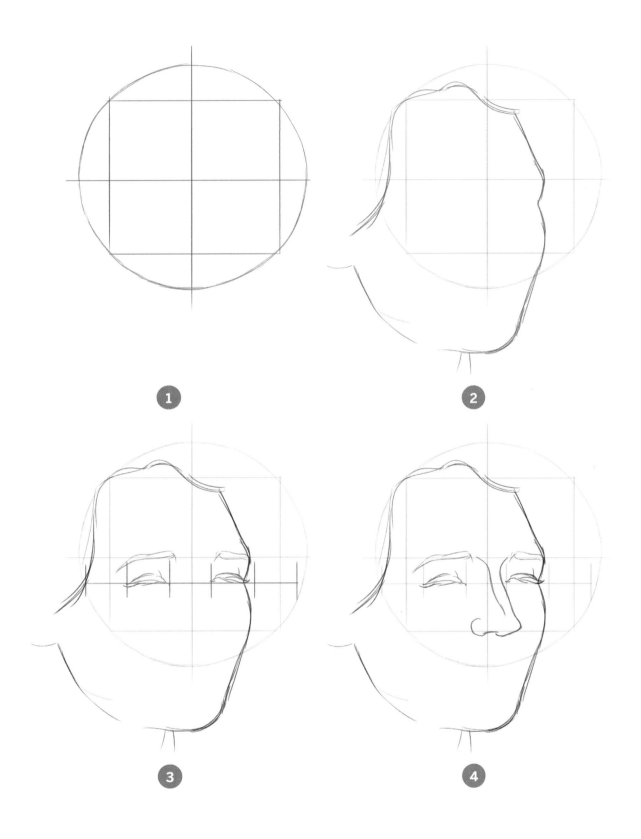

1

2

3

4

continued >>

5. **Add the mouth.** Draw a toothy grin. The curve of the lips is adjusted because of perspective. The edges of the mouth line up with the irises, and some wrinkles and creases emphasize the expression.

6. **Add the hair.** Lay the primary lines for the hair's flow and the eyebrows. Use the top left corner of the square guide from Step 1 for the corner of the hairline.

7. **Add more definition.** Use hatching to give the face depth, with darker sides facing the viewer. Add shading to the nose's left side—use crosshatching with lines that extend from the nose to the cheek, intersecting lines that follow the shape of the nose.

8. **Add shading.** As usual, include variation in the darkness and space between your hatching, as well as crosshatching, to differentiate between darker and lighter parts of the face.

TIP

Always remember that your 2D drawing is a depiction of a 3D form. The direction of your mark-making can really add to the illusion of solidity.

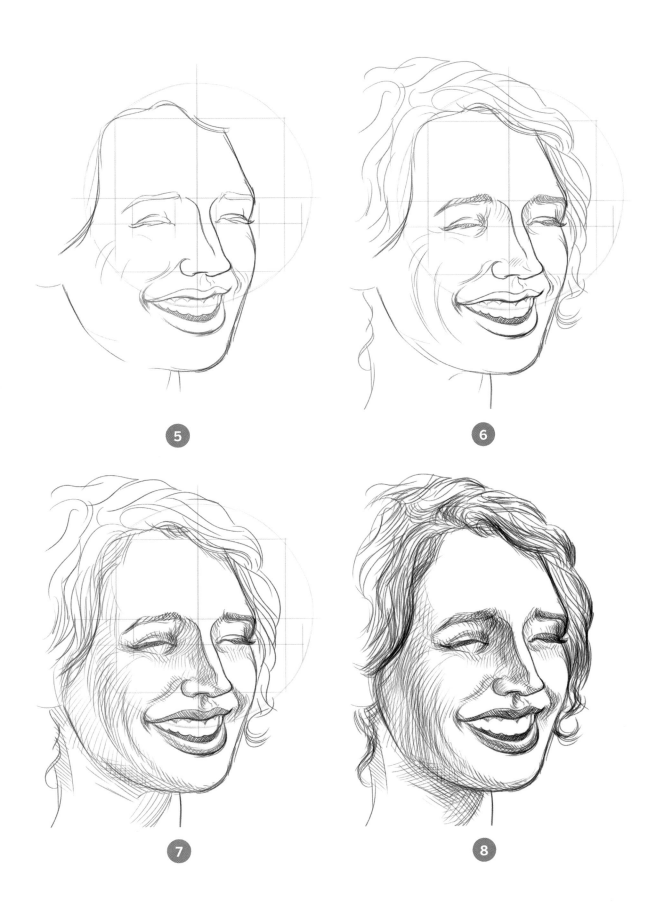

Exercise 3: Sorrow

You can use changes in the upper and lower halves of the face to depict different emotional states. The eyes and brows might say one thing while the mouth says another. Usually the eyes are where genuine feeling is, while the mouth is often performative.

1. **Sketch the basic shape.** This time, we'll try a more complex perspective. The head will face downward at an angle. Use sketched guidelines that curve slightly.

2. **Add basic features.** Notice how the example conforms to the rules of the original frame guidelines we've been using, but we're depicting things with slightly more complexity.

3. **Add definition.** Darken your primary lines and add more to increase the depth of the skull and features that stick out.

4. **Add basic shading.** The light source is above and toward the right, so the shadows are farther away from the viewer. However, you'll notice that some parts still have darker sections, such as below the eyes or a bit on the cheek.

5. **Add shading.** Start adding lines to the hair to show its flow and include hatching along the neck, which is shaded by the hair. The side of the forehead, cheeks, chin, upper neck, above the eyes, the bridge, and upper lip are also shaded in this example.

6. **Finish the details.** Thicken and darken lines as needed and add hatching and cross-hatching to accomplish the shading you're aiming for.

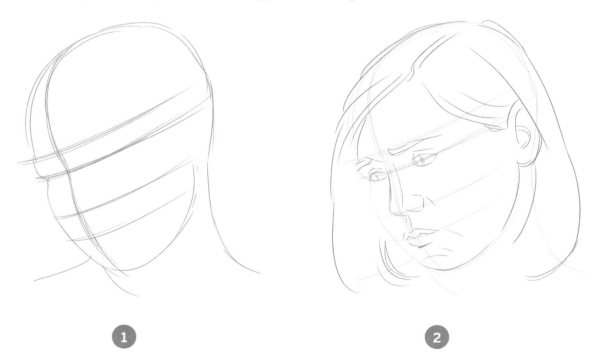

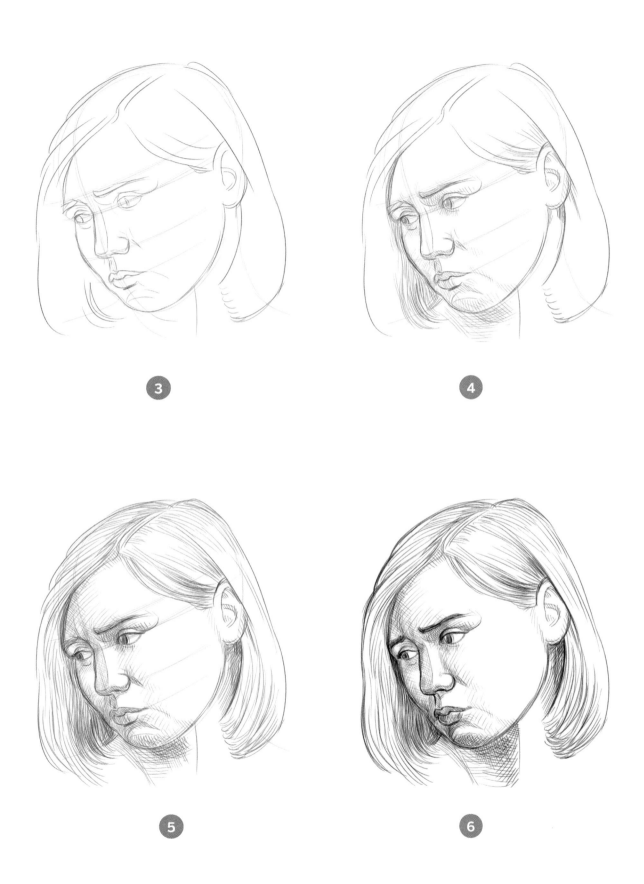

Exercise 4: Anger

The appearance of anger typically involves the brow muscles pulling down and inward, eyelids lowering, cheek muscles tightening, and lips curving or pouting. Putting together variations of mouths along with angry eyes will display different feelings: Imagine eyes filled with anger over a mouth that is smirking versus a mouth that depicts sorrow.

1. **Create the frame.** While setting up the guidelines you'll need for placing features on the face, try creating a basic outline that is looser than the one we used in exercises in earlier chapters. (At this basic stage, always feel free to erase and try again until you get lines that look good to you.)

2. **Sketch the basic shapes.** The face in our example depicts a more subtle type of anger—a sort of disapproving feeling. Use a different reference if you'd like to explore a more intense anger, though it may be challenging because stronger emotions involve more extreme changes in features.

3. **Add basic shading.** Start the hatching process for the lips, eyes, nose, and brows. You might be starting to get the hang of adding these basic shading lines around the various features.

4. **Add definition.** Longer, lighter lines around the forehead, cheeks, neck, and chin will help portray the shape of the head.

5. **Add detail.** Include more lines in the hair to show its volume, flow, and shape. Give the neck, cheeks, forehead, and lips more hatching.

6. **Finalize.** After you're done shading, you can darken primary lines such as the jawline and cheeks or the edge of the hair that frames the face.

1

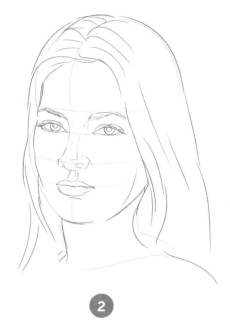

2

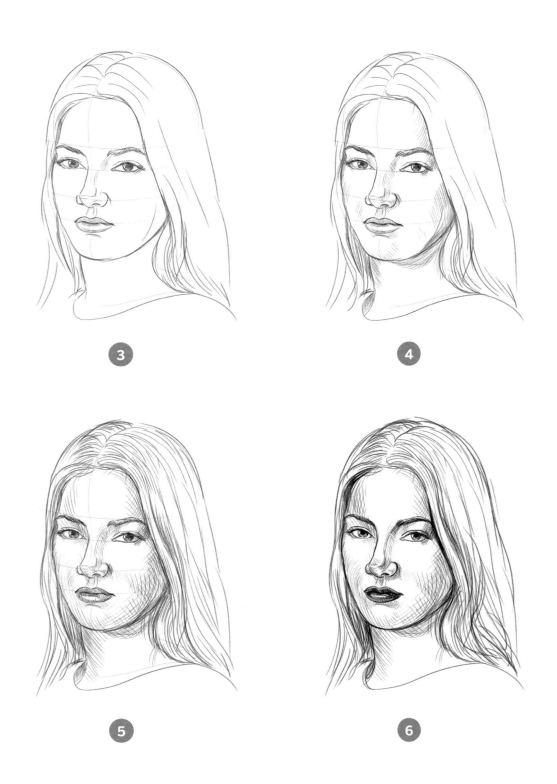

Exercise 5: Fear

A joyful expression typically involves the forehead muscles pulling upward and the brows moving inward. With surprise, on the other hand, the forehead muscles pull up, with the eyes wide open. Fear often incorporates similar elements with the upper face muscles, but the lower muscles act differently, often pushed downward. In this exercise, you'll depict a face with a scared expression.

1. **Create the frame.** Feel out the main guidelines for this drawing, using the example as a reference. You want it to appear as if the subject is turning their head to one side, reacting with fright.

2. **Sketch the basic shapes.** The lips should be open, the eyes wide, and the brows furrowed. Use the guidelines to help retain perspective.

3. **Add the hair and teeth.** Ideally, you want a bit of space between the top and bottom teeth, to show the mouth is opened slightly.

4. **Add definition.** Fill in the eyes and add eyelashes. Start hatching in shading, with thinner, darker patches of lines toward the right to set up a sense of lighting from the front-left of the frame. The lips and nose should start to get some shading; remember to add some wrinkle lines to the forehead to emphasize fear.

5. **Add more shading.** Start filling in more hatch lines around the eyes, the right cheek, and the neck. The hatch lines will generally be more spread out as you move left.

6. **Finalize.** Darken the primary lines as desired and fill in the hair more, including the eyebrows.

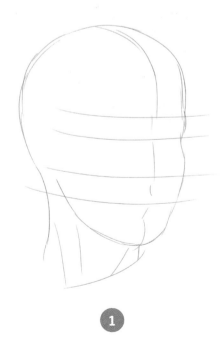

1

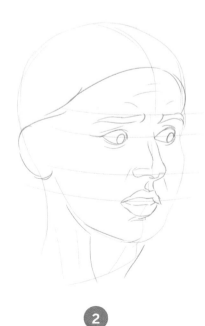

2

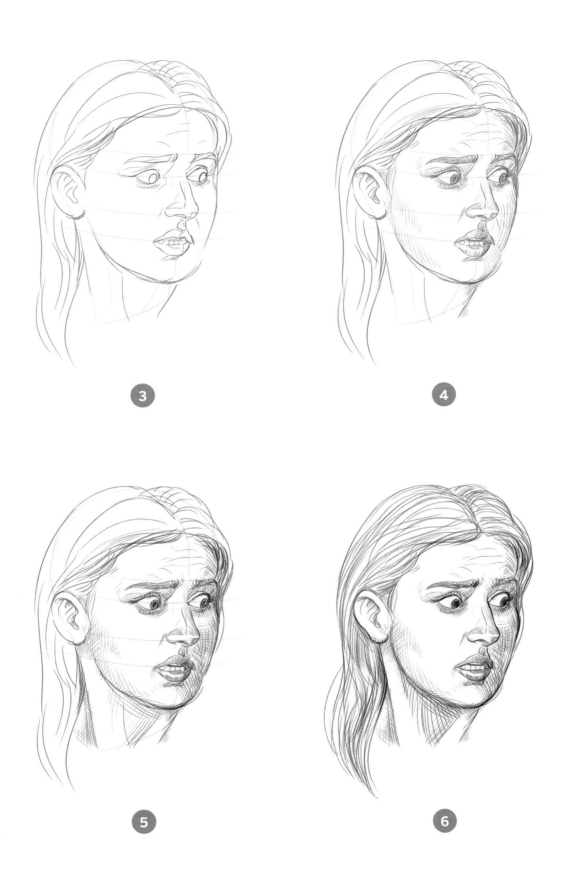

Exercise 6: Love

The act of drawing a portrait is itself a loving gesture; seeing someone clearly—without bias—involves at least some degree of love, regardless of what emotion they're displaying. Love comes in many forms, with many nuances to how it is expressed.

1. **Create the frame.** This angle is more straightforward than others in this chapter, so feel things out yourself with your guidelines.

2. **Sketch the basic shapes.** Add the brows, eyes, nose, lips, ears, and chin. There's a lot more linework around the mouth because they have a big, warm smile.

3. **Add details.** Add more lines to define the nose, cheeks, mouth, and eyes. Start solidifying the hairline, too, as well as the main lines in the ear.

4. **Start shading.** Fill in the eyes and brows, start working on the hair, and give some light shading around the various wrinkles and creases.

5. **Add the facial hair.** These lines are similar to hatching but pull them down slightly past the end of the jawline, curling in different ways. Add more light shading to the nose.

6. **Finalize.** Fill in the hair on the head and face, along with primary lines such as the chin, jaw, and cheeks. Add more hatching and crosshatching in darker sections; remember to curve the lines to generate that illusion of shape in the face around the creases created by the smile.

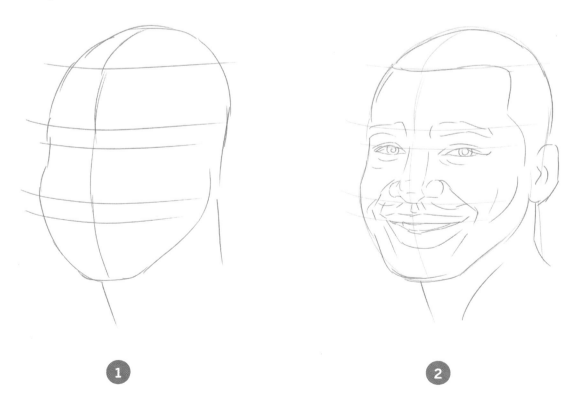

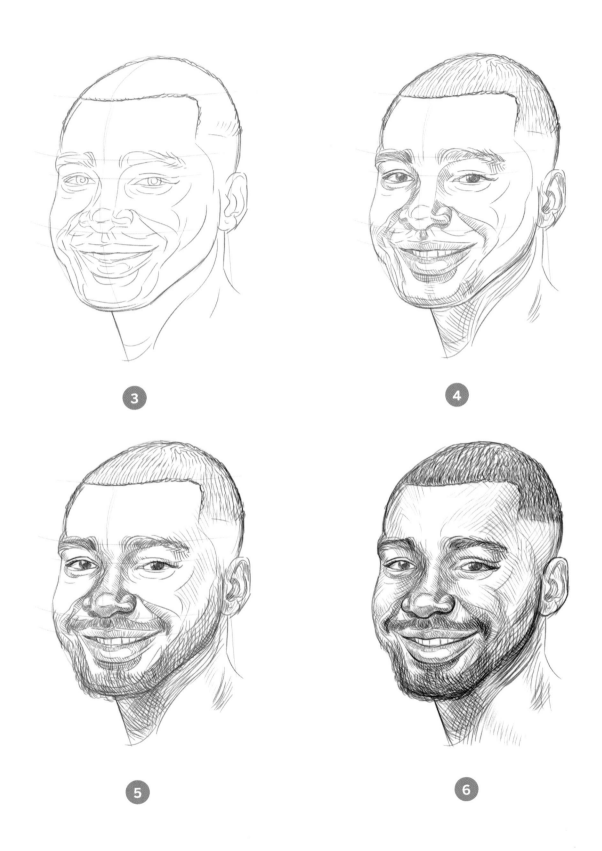

3

4

5

6

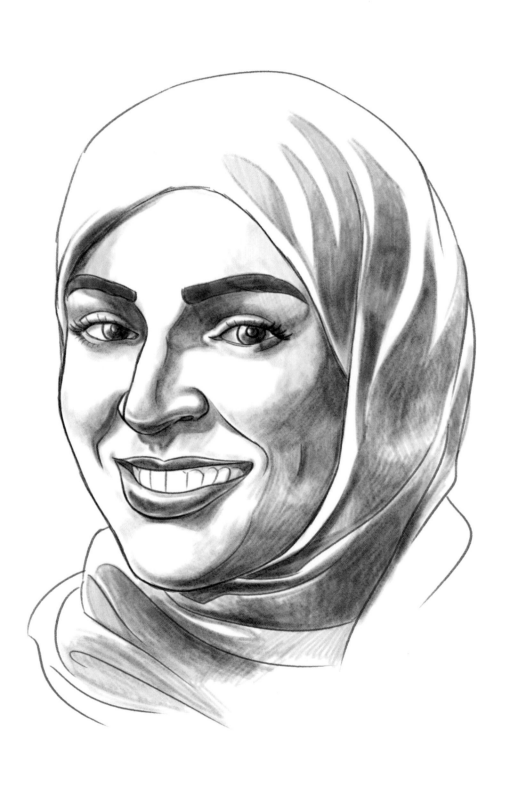

Exercise 1, page 66

CHAPTER 5

Shading and Light

A meaningful way to upgrade your results with any kind of drawing is to improve your skill in portraying shading and light. It may take a while to feel confident with it, but light is key to depicting objects in a way that feels three-dimensional. In this chapter, we'll focus on practicing shading.

Exercise 1: Pencil Shading

For this exercise, you can return to a portrait you drew in chapter 3 (this isn't necessary, but it may help you focus more on shading). In the following steps, we'll walk you through using a pencil to shade in detail, further fleshing out your drawing.

1. **Outline your image.** Pick a drawing that has clear outlines you like for an easy-to-read image. If the image you've selected is in pencil, use ink to darken the primary lines, and erase the rest (you can do this with any exercise in this chapter).

2. **Identify the light source.** For this exercise, pick where you want the light to come from, but somewhere slightly above the subject is recommended. In our example, the light source is above and somewhat behind the subject.

3. **Add basic shadows.** Feel free to study lighting references. Something spherical, if not a literal human face, can help give you an idea of how shadows form on rounded objects. Lightly sketch out basic lines along the shapes on the face to plan your shading.

4. **Fill out the shaded areas.** Imagine the light as straight lines coming from the light source. Any objects that stick out perpendicular to those lines will create shadows; the further the shape sticks out, the longer the shadow. Try to darken areas that are more covered from where the light is coming from. In this example, the area below the chin and the bit around the eye on the left are darker spots.

5. **Soften the edges.** Soften your shadows by using a smudge tool. Blending around areas of different shades to smooth them together will create a more natural appearance.

6. **Finalize.** Continue to smudge and smooth out your shadows as desired. Add extra sketch lines to smudge over, if needed. The wider the range of shades you work in, the richer the result.

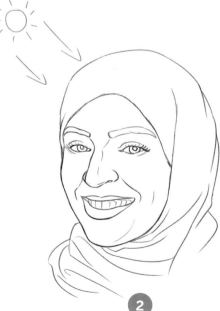

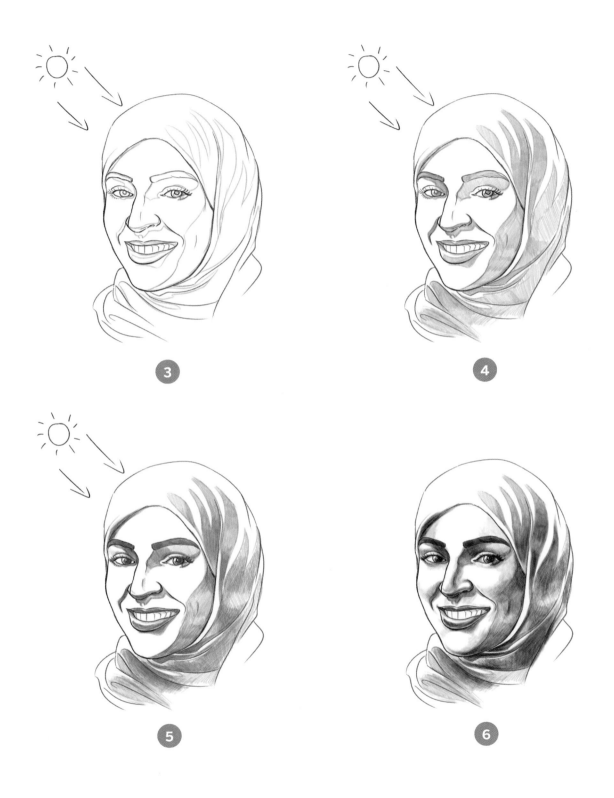

Exercise 2: Shading with Ink

Like in Exercise 1, you can revisit an earlier portrait, but this time, you'll practice shading it in with ink. This will help you get a feel for how ink works differently than pencil when applying shading details.

1. **Outline your image.** Like in Exercise 1, select an image with clear outlines. We recommended that you pick a drawing with lots of smaller spaces and shapes to fill with shadow, rather than large, smooth surfaces; ink is a better medium to work with for the former.

2. **Identify the light source.** Again, you'll want to stick with light mostly coming from above and a bit behind your subject. This will cast a slight shadow across the face.

3. **Add basic shadows.** Because you're using ink, focus on darkening lines that will have some shadow around them. Make your marks slightly below the lines of the shapes, or in a way that opposes the light source. These should be thick lines.

4. **Add light shading.** Using smaller, lighter strokes of ink, add more shading to various sections. A common place to add hatching is below the neck, and smaller wrinkles and creases or bits of hair can use some light lining, too.

5. **Fill in more shading.** Incorporate some crosshatching into darker spots and add longer strokes to areas with some amount of shade, keeping your pressure light. In our example, we've focused on areas that would have patches of light shadow, such as below the creases of the cheeks and eyes.

6. **Finalize.** You can add any last touches to shading as desired, such as around the collar of the shirt in our example, or some extra crosshatching on various areas of shade.

1

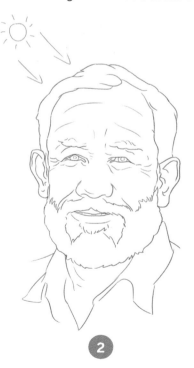

2

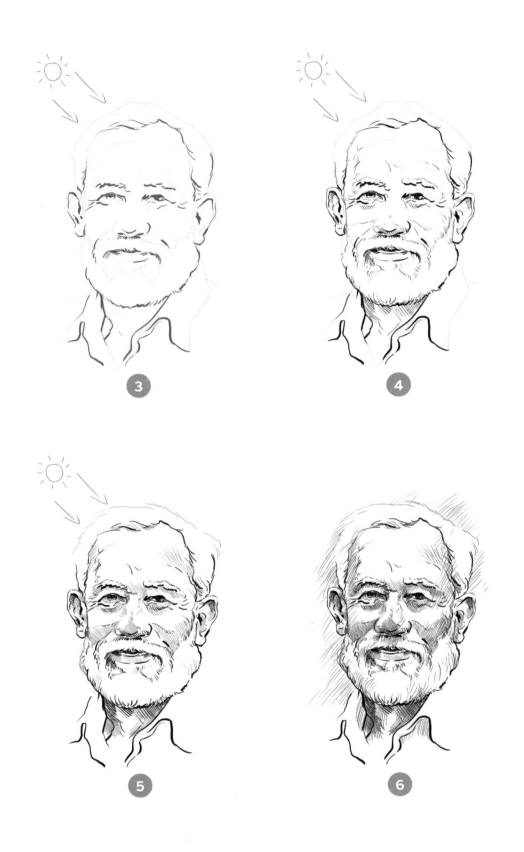

Exercise 3: Shading with Watercolors

Watercolors are exciting to work with because they encourage freeform strokes, and the way they spread and dry can add a nice organic touch to your painting. They can take some time to dry, however, so they're a bit slower to work with than some other mediums. It also takes some practice to get the hang of how to achieve the specific shades you want. For this exercise, however, you'll only be worrying about a single color of paint and basic shading. As noted in chapter 1, you can darken watercolor paint by adding more pigment to your mix, or you can lighten it by adding more water. You can also apply darker shades by layering them on top of previously painted areas, which is the main technique we'll explore here.

1. **Create the outline.** Using watercolor ink, create a portrait outline. We recommend a subject with long, straight hair. If you don't have watercolor ink specifically, your outline may become smudged or blurred. You could use a darker shade of watercolor and a thin brush to sketch your outline instead—just make sure you wait for it to dry before continuing.

2. **Add primary shading.** Apply a base layer of paint to generally fill in the portrait, including an extra layer in some spots to emphasize where shadows will form.

3. **Add an extra layer.** Give some spots in the hair some long, thinner strokes to add depth.

4. **Deepen the shadows.** Darken your paint with more pigment or start a new batch with a much darker shade. Apply a dark coat to places with the deepest shadows, such as around the neck, the inner edges of hair, and under the brows.

5. **Fill empty space.** Apply a final lighter layer over the hair and any areas that have been left empty or too light.

6. **Finalize.** After it dries, you'll have a portrait that looks very different from the others you've made so far!

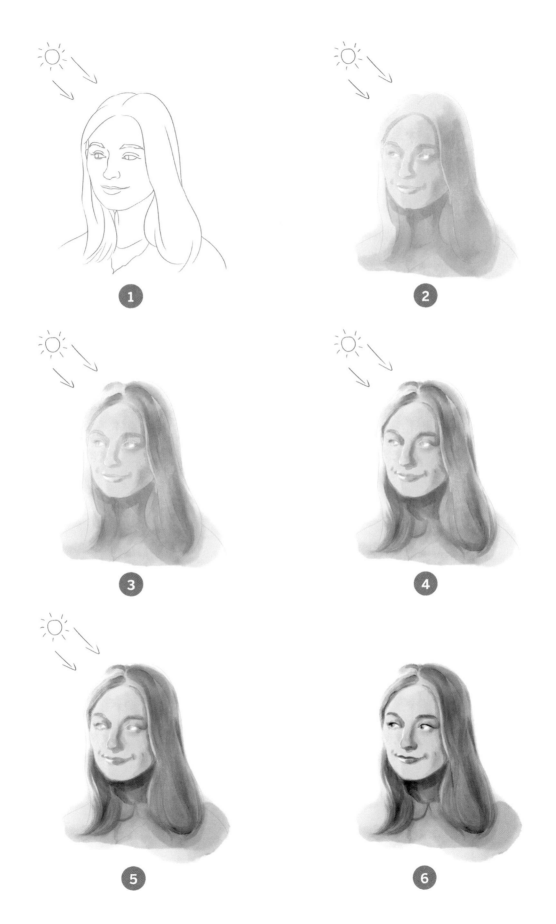

Exercise 4: Light from Above

A benefit of working with a light source above your subject is that shading will be symmetrical with high contrast. In this exercise, shade a portrait to suggest a light source directly above the subject. Going forward, the steps have been written to assume you're working with pencils and will refer to smudging, but you're welcome to use watercolors or another form of shading.

1. **Outline your image.** Another image with clear primary lines will work best, especially one directly facing the viewer.

2. **Identify the light source.** The light for this drawing will be placed directly above the subject. Imagine those straight lines of light falling down on the face—what shapes in the face would block light and cast shadows?

3. **Add basic shadows.** Start adding sketch lines to lay out where your shadows will begin or end.

4. **Add light shading.** Because our lighting creates more extreme shadows, you'll be drawing a lot of long, vertical hatching lines. The usual areas you may be familiar with will have shading below them, but those shadows will cast longer.

5. **Add darker shadows.** Incorporate crosshatching in wider patches and add more lines closer together in smaller spots with more intense shadow.

6. **Finalize.** Use smudging and vary the shades present to enrich the shading further.

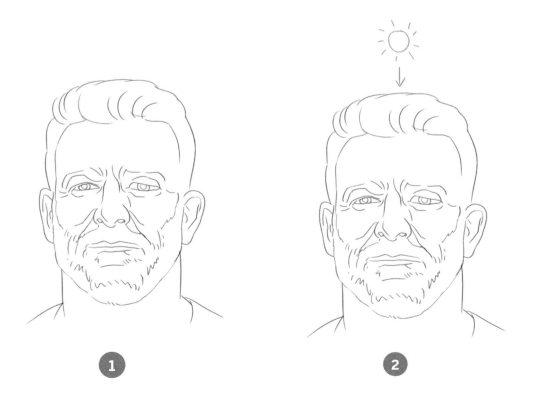

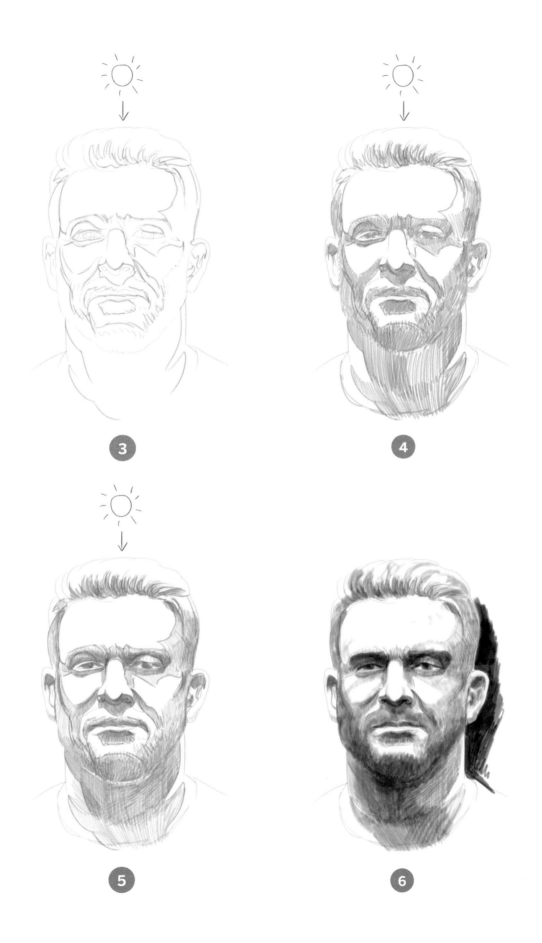

Exercise 5: Backlight

When depicting a subject who is backlit, the subject will generally be shaded darker; this usually means that the style of shading will be harsher.

1. **Outline the subject.** Pick a previous portrait directly facing the viewer, or outline a new one.

2. **Identify the light source.** Our light source is wide, so the subject will be lit on both sides with shadows falling on the front.

3. **Add basic shadows.** The sketch lines for where shadows will fall should be fairly symmetrical. You'll need to identify the primary shape of the sides of the face, from the edges of the forehead down to the cheeks and jawline.

4. **Start shading.** You'll be using very long hatch lines here to lay down a base layer of shadow. Remember to leave blank the spaces that are the most horizontal, such as the sides of the chin.

5. **Layer more shading.** Start crosshatching down the middle portions where the shading will be darkest.

6. **Finalize.** Incorporate blending and smudging as desired, as well as more hatching. In our example, many lines intersect at less extreme angles; we're trying to create the illusion of shades that don't contrast as harshly.

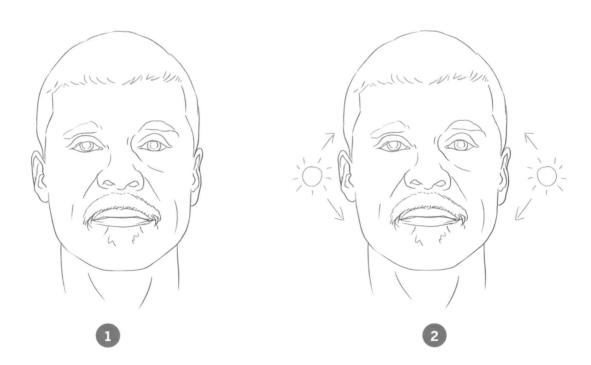

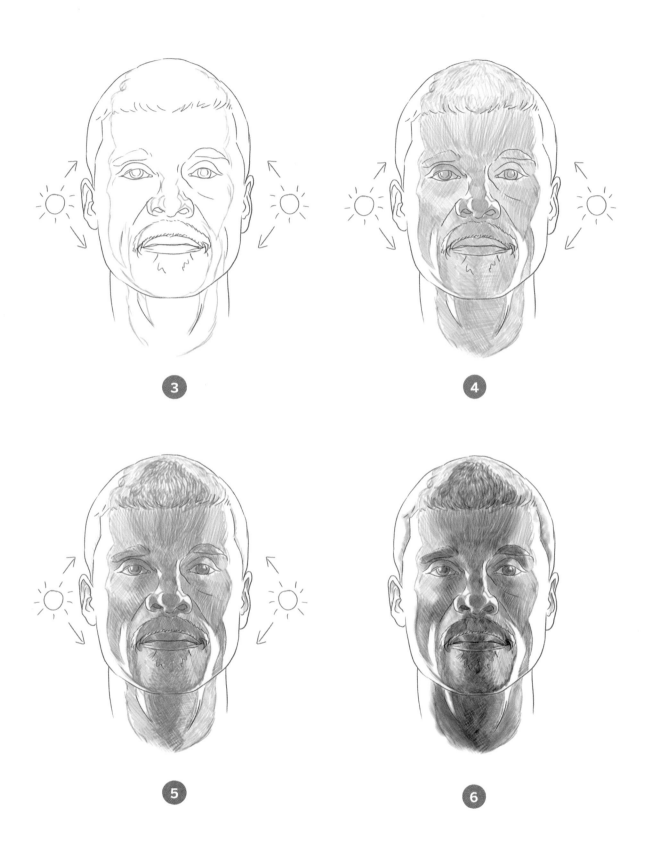

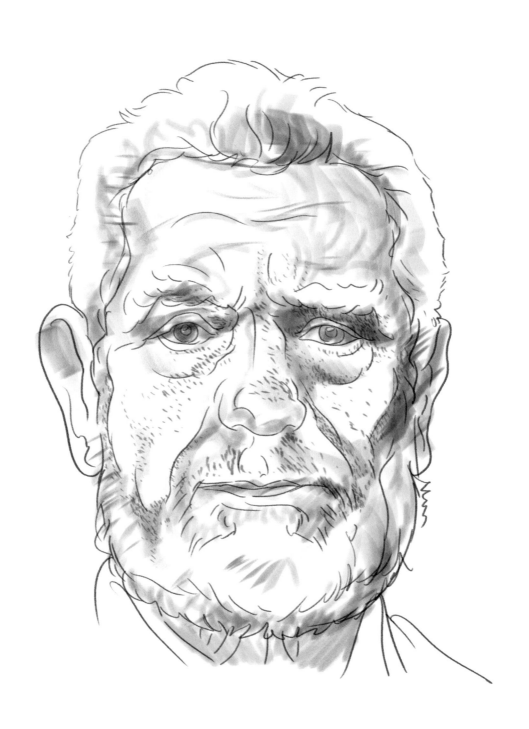

Exercise 6, page 88

CHAPTER 6
Texture and Detail

The final major step in learning the basics of portraiture is incorporating details. Making hair look realistic and adding texture to skin and folds to clothing can all take a portrait from vaguely resembling someone to depicting an instantly recognizable face. It takes a lot of work and practice to achieve this layer of polish.

Exercise 1: Actual vs. Implied Texture

Frottage refers to creating a texture or image by using pencil or charcoal and rubbing it on an object that has been placed under paper. This technique allows you to directly compare the object's actual texture—the literal surface itself—to its implied texture, the illusion of the surface's shape left behind on the paper. This exercise will help you understand how texture in drawing can be depicted.

1. **How to Use Frottage.** Take a dried leaf, a thin piece of tree bark, or a dried flower and place it on a flat surface beneath your paper. Carefully rub your medium—typically pencil or charcoal—across the paper, lightly pressing against the textured object underneath. The result is a shaded impression of that texture.

2. **Create the outline.** Pick an unshaded portrait you've already sketched, or start a new one from scratch using the techniques in earlier exercises. Here, we've made a portrait with a new pose and angle, and it will have a light source coming from the right-hand side of the frame.

3. **Add basic shadow.** This should be a familiar process by now! After you've determined the source of your light, add basic shadow lines that you'll use to guide the shading you'll incorporate.

4. **Add texture shading.** Add a textured surface below your drawing (for example, a piece of dried tree bark, some bubble wrap, a bit of sandpaper, a dried leaf, or even a paper towel). Test it on scratch paper first to make sure you like the texture. Now, fill in a basic shadow using your previous shadow lines, but rather than hatching, use frottage to create a uniform texture as the base shading.

5. **Add detailed shading.** For the darker shadows, repeat the frottage technique with a different texture (or change the angle), applying slightly more pressure.

6. **Texture the lips and hair.** Use yet another texture to fill in the brows, hair, lips, and other potential dark spots, such as below the chin or nostrils, using the frottage technique. Make this layer a shade darker than the previous one.

7. **Finalize.** Using the same technique, touch up any areas that could use some shading.

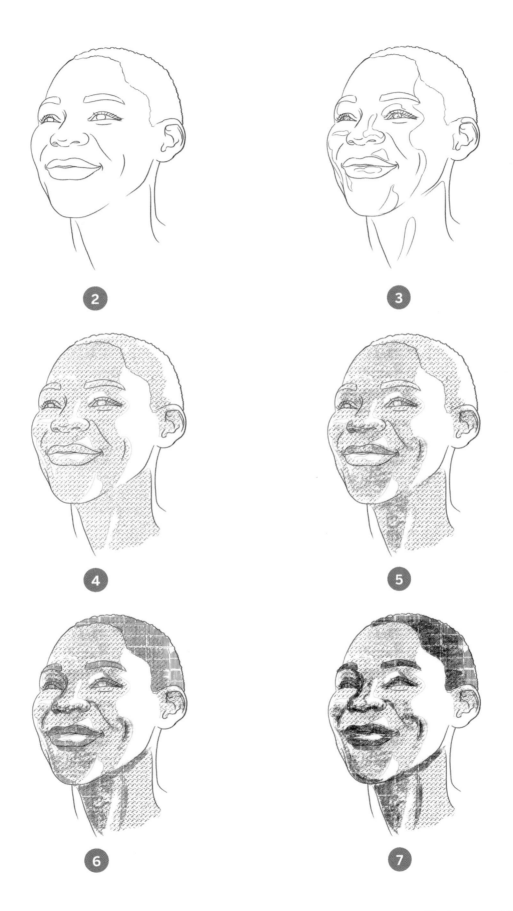

Exercise 2: Texture and Light

When considering how texture appears, think of it in terms of how light hits it. Light hits a smooth surface in a different way than it hits a gritty one, for instance. Paying attention to this aspect as you create different types of textures and surfaces will also help you portray aspects of a person's face. Skin and hair will have varying textures. In this exercise, we'll focus on closer details of a face's texture.

1. **Create the outline.** For this exercise, we'll hone in on the details of the lower face. Create an outline shape of a chin, lips, nostrils, cheeks, and jaw. The lighting will be neutral, in front of the subject at approximately eye level but slightly above the subject.

2. **Start texturing the mouth.** Add some shading to the inner edges of the lips and begin to texture and shade the area right below the bottom lip, as well as the chin. Does this person have facial hair or visible pores? You can start with some smudging and then layer small dots and strokes on top.

3. **Add detail.** Fill in the space around the nostrils and upper lip with texture and shading, then start working on the lips themselves. Start with some smudging, then work lots of compact strokes and dots into these spaces. Aim for a natural appearance, not robotically uniform. The areas right below the bottom lip and around the bottom edges where the nostrils open will be dark, while the space above the upper lip will be light.

4. **Fill out the lips.** Add more dots above and below the lips and on the lips themselves. Remember to create lines that travel vertically across the whole surface, which will imply a rounded shape. Leave some blank space at the top of the bottom lip for "shine," and some thin, blank space right below it will provide depth.

5. **Add detail.** Extra bits of shadow around the edges of the nostrils, as well as more small dots and lines for hairs and pores, will round things out.

6. **Finalize.** You can use some smudging as you go for less populated areas of the drawing, but in the end, you want lots of small strokes and dots laid onto those smudged areas to give the drawing organic details and texture.

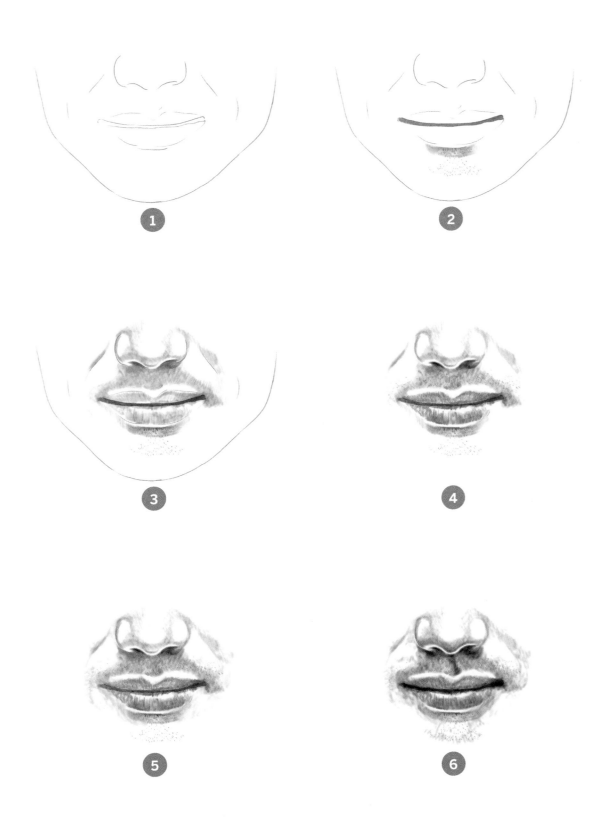

Exercise 3: Adding Detail to Eyes

Think of the eye as many smaller parts and focus on them one at a time—not just the pupil, iris, and sclera, but also both eyelids, the tear duct, eyebrow, eyelashes, and brow ridges.

1. **Create the outline.** Using the guide circles and lines introduced in earlier chapters, create the primary lines of a closeup of an eye.

2. **Add the lashes and start the iris.** The lashes should curve outward from the center of the eye. Use parallel lines to create thicker lashes. For the iris, think of the way light looks like a messy web when it passes through the surface of water.

3. **Add shading.** Use smudging to incorporate a layer of shading. Ink the lines you've created so you can work freely. Remember to give the tear duct shadow, and for the iris, leave the "web" of light clear of shading.

4. **Deepen the shadows.** Darken the lines where shadows are formed. Thicken some of your eyelashes and ink the ones you're happy with.

5. **Smooth out the texture.** Use smudging to create texture around the eye. Leave blank space in vague lines to imply skin around the eye and add extra shading to the inner eye, if you wish.

6. **Finalize.** Use darkened lines and smudging to smooth over more texture and shadow.

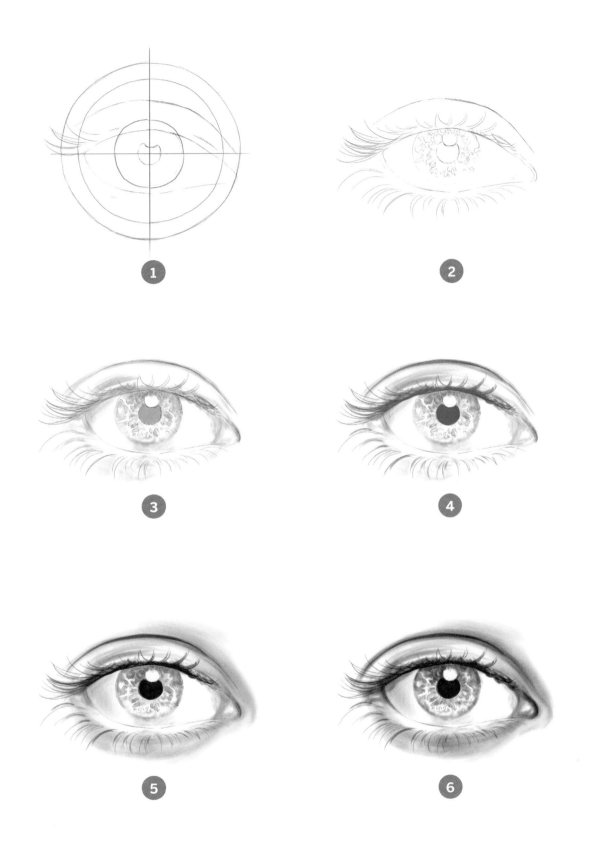

Exercise 4: Drawing Realistic Straight Hair

Hair can have all manner of textures, as well as shapes, volume, and lengths. This exercise will help you depict straight hair, a good starting place.

1. **Create the outline.** For this example, we've designed an outline in which hair covers a lot of the face, flows far and long, and overlaps and curves around itself. This design will provide lots of opportunity to practice straight hair in different positions. Ink your primary lines.

2. **Start shading the hair.** Use smudging to create longer, thin patches of smooth shading that create a sense of flow to the hair. Make darker spots in areas where more shadow would exist, such as behind the jaw or under other layers of hair.

3. **Add detail.** Create dark, thin lines that run beside one another to flesh out the direction of the hair's flow and start giving it texture. Consider inking the lines you like most.

4. **Fill in volume.** Back to smudging! Use the lines you created in the last step and fill more space around them, following their flow. Create darker patches in areas with shadow, such as places where the hair curves or folds in on itself.

5. **Finalize.** Repeat Steps 3 and 4 as desired to add further detail to the hair.

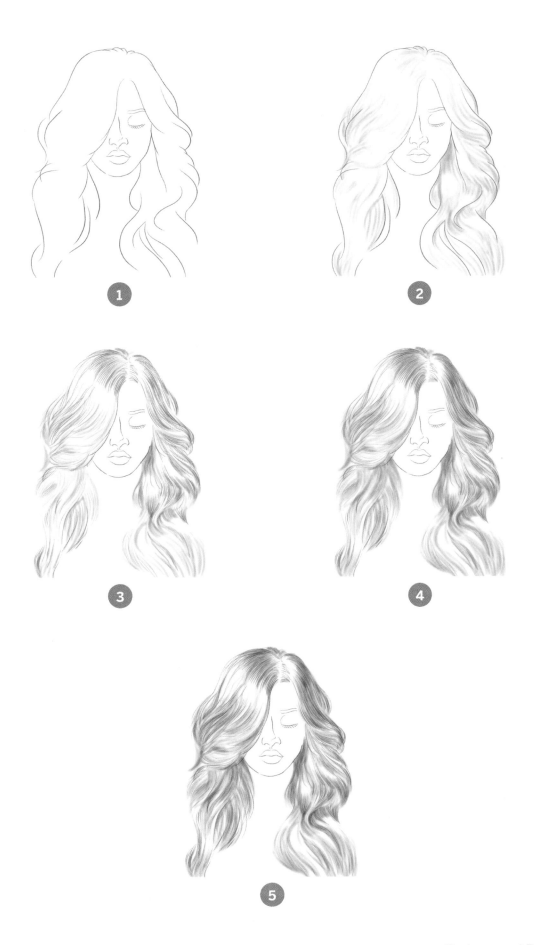

Exercise 5: Drawing Realistic Curly Hair

Curly hair follows the same physics and rules of straight hair, just with more rounded curves curling its shape. It's especially useful to observe photographs to see how curly hair looks. Light bounces off curly hair in a different way than straight hair, but in ways that follow a pattern of sorts. For this exercise, practice with a close-up of curly hair.

1. **Create the outline.** Your subject should have naturally curly hair, and you'll want to practice with a large volume of it. Start by forming a loose outline with a series of smaller lines, giving most a hooked curve.

2. **Start filling in the hair.** Use a sequence of many small, curved lines, such as hook shapes, half circles, and crescents, to fill the general space of the hair. Smudge them over with a blending tool—this will serve as a base layer for the hair.

3. **Add shading.** To create a sense of depth, repeat Step 2 but focus on darker lines in areas where light is somewhat blocked, such as where the hair touches the skull. Branch this out a bit in organic ways so it doesn't look too uniform or flat, and give it some smudging.

4. **Fill in the hair strands.** Apply another layer of lines like in Steps 2 and 3, making them vary in thickness. Don't smudge or blend them so they stand out more as individual strands of hair.

5. **Cover the empty space.** Fill the empty space with some light lines. You can do so in a variety of ways, so choose whatever you prefer (repeat Steps 2 and 3 but with a lighter shade, for example).

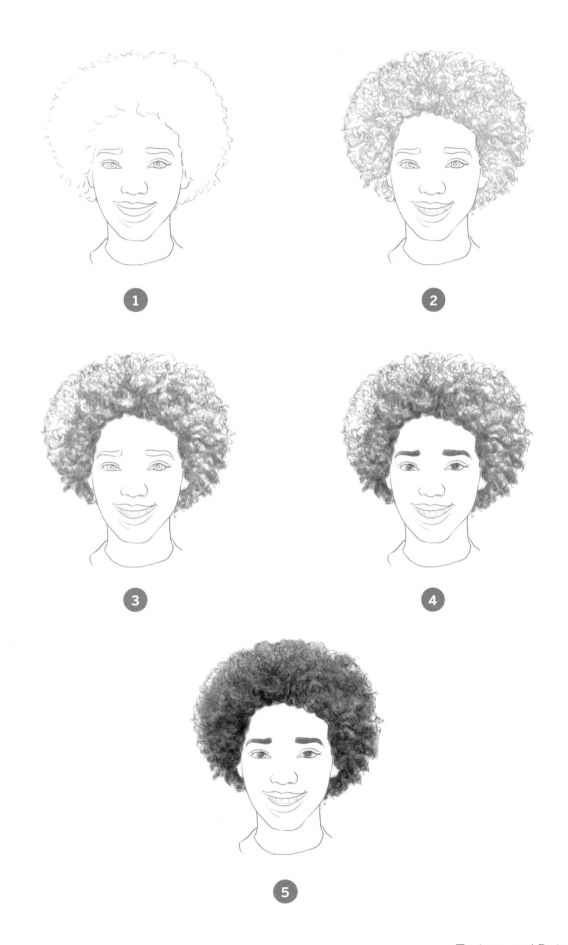

Exercise 6: Adding Texture to Skin

Studying up-close, highly detailed photographs of human faces will help you learn how to depict skin texture, which varies greatly. Individual spots on a face will have different textures—consider wrinkles, pores, freckles, blemishes, and more. When depicting skin textures in detail, it's important to keep your light source in mind because they will look different based on your lighting. In this exercise, focus on drawing both smooth and rough skin texture.

If at any point you're not satisfied with your outlines, ask yourself if you're rushing or consider revisiting some of the basics. Don't be afraid to use guidelines and frames—many artists use these important tools.

1. **Create the outline.** This is it—the final exercise of the book! By this point, you've ideally developed your own process of outlining a portrait. For this exercise, create a subject that is noticeably older—this gives you a lot of opportunity to work with texturing and shading because of the details of their skin.

2. **Add basic shading.** After inking your outline, begin applying shadow lines and smudging them. Remember to maintain a consistent sense of where the light is coming from.

3. **Deepen the shadows.** Repeat Step 2 with a noticeably darker shade in areas with more shadows. Consider the structure of the skull, the creases and folds of the skin, and how the hair affects the shadows in your subject. Smudge and blend to keep an organic feeling.

4. **Add details and finalize.** Add pores, wrinkles, and individual hairs. Ink the lines you want to keep. Consider applying a final layer of smudged shading to enrich the shadows.

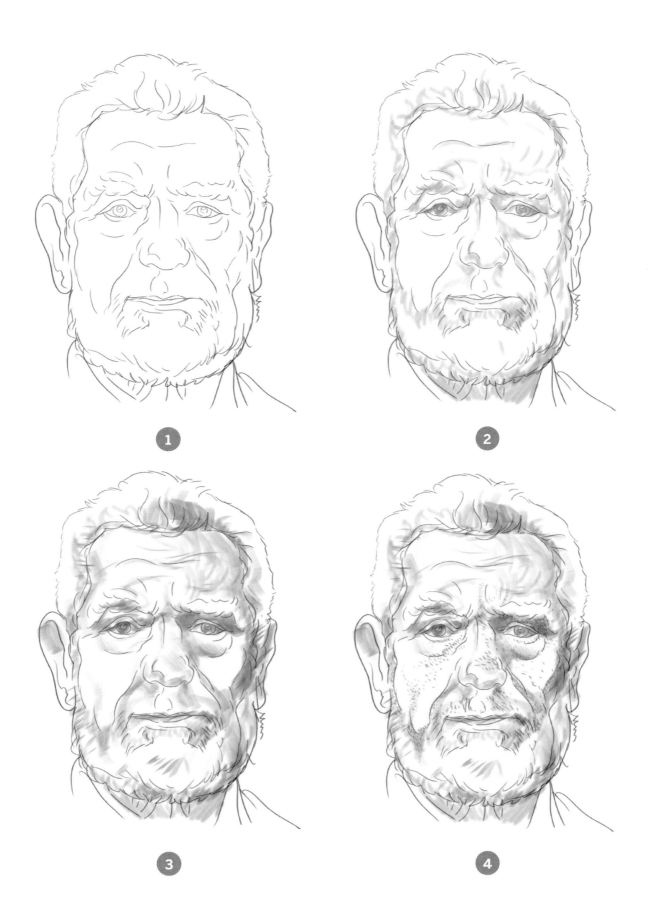

GLOSSARY

¾ angle: A perspective in which the subject is facing forward at a roughly 45-degree angle rather than head-on

Blending: The act of smoothing two colors, shades, etc. so they transition into each other

Bridge: The rigid, bony part of the nose, which forms its main shape and structure

Brow line: The horizontal line on which the eyebrows line up

Contours: The lines representing the out-line or primary shape of an object or subject

Crosshatching: A shading technique in which two sets of parallel lines intersect each other to create a darker tone

Crosslines: In this book, the two perpen-dicular intersecting lines that are used as the initial guidelines in a drawing

Definition: Adding clarity to the appear-ance of your drawing's subject, often through primary details

Depth: The way lines create a sense of three-dimensional space, with parts of the image appearing to be closer or farther away

Frottage: A technique for creating texture or an impression by rubbing a pencil or

charcoal on a piece of paper that has been placed over an object

Hatching: A shading technique in which parallel lines are drawn close together to create a sense of shade

Highlights: The spots in a drawing with the lightest tint, where there is the least amount of shadow

Iris line: The horizontal line where the irises line up; the part of the eye that has color

Jawlines: The outlines of the lower jaw, stretching from just below the ear and meeting at the chin

Linework: Marks made using a pen or pencil

Loomis technique: A way to use crosslines to help with the placement of facial features

Perspective: The manner in which a drawing implies depth and the position of objects within it

Portraiture: The act of creating portrait art

Profile: A depiction of someone from the side, usually at a perfect angle

Proportion: The way objects relate to each other in size or scale

Shade: How dark or light a hue appears, based on the black added to it

Smudging: The act of smoothing pencil strokes over for a softer look, often done using a tool

Texture: The way lines in a drawing create the illusion of three-dimensional shape and structure

Tint: How dark or light a hue appears, based on the white added to it

Tone: How dark or light a hue appears, based on the gray added to it

Value: A measure of how light or dark a specific hue is

RESOURCES

Books

30-Minute Drawing for Beginners (Rockridge Press)
This comprehensive guide to drawing all sorts of different things is a great next stop on your artist journey.

30-Minute Watercolor Painting for Beginners (Rockridge Press)
If the exercise involving adding color piqued your interest, explore watercolor painting with this book. It's brimming with beautiful and deceptively simple watercolor exercises, including portrait painting.

Anatomy for the Artist by Sarah Simblet
The fantastic collection of photo references in this book will allow you to study the human form at home rather than taking a life-drawing class.

Drawing the Head and Hands by Andrew Loomis
This classic reference for portrait drawing is still well worth reading today. Most current books on the subject refer to Loomis's teachings.

Human Anatomy for Artists: The Elements of Form by Eliot Goldfinger
This extremely in-depth, and very weighty, guide to human anatomy is an invaluable resource for the artist looking to make scientifically accurate illustrations.

Online Resources

FreePik.com, Pexels.com, Pixabay.com, Unsplash.com
These royalty-free stock image websites are a great resource for portrait-drawing references.

Pinterest.com
For a range of study material, this online scrapbook website is fantastic for sourcing references to try sketching from, whether to copy portrait-drawing examples or reference from photographs. If you're posting your progress online, remember that it's good manners to link back to your references and not to use unattributed work for anything commercial.

INDEX

T

Texture
 actual vs. implied, 78–79
 defined, 3
 and light, 80–81
 skin, 88–89

¾ angle, 28–31
Tint, 4
Tone, 6–7

V

Values, 4–5

W

Watercolors, 3, 5